SIXTIES SPOTTING DAYS AROUND THE EASTERN REGION

SIXTIES SPOTTING DAYS AROUND THE EASTERN REGION

Kevin Derrick

AMBERLEY

This edition first published 2016

Amberley Publishing
The Hill, Stroud
Gloucestershire, GL5 4EP

www.amberley-books.com

Copyright © Kevin Derrick, 2016

The right of Kevin Derrick to be identified as
the Author of this work has been asserted in
accordance with the Copyrights, Designs and
Patents Act 1988.

ISBN 978 1 4456 6067 7 (print)
ISBN 978 1 4456 6068 4 (ebook)

British Library Cataloguing in Publication Data.
A catalogue record for this book is available from
the British Library.

Typesetting by Amberley Publishing.
Printed in the UK.

Contents

Introduction

In this volume of *Sixties Spotting Days* we take a journey around the Eastern Region. Many areas of the region had seen electrification during the 1950s and the region had been early in placing orders for replacement diesel locomotives and diesel multiple units. As a result, steam was to vanish quickly from the routes from Liverpool Street and Fenchurch Street, while many lines in East Anglia and Lincolnshire would be closed completely as the famous Doctor's recommendations took effect during the decade.

Change was, of course, happening all across the country, with the management of the Eastern Region anxious to promote their region as a modern and efficient railway. The effects of the LNER's pre-war publicity were still in the minds of many travellers used to seeing their East Coast Main Line expresses hauled by a Gresley, Thompson or Peppercorn Pacific. With large orders placed for as yet unproven diesel designs, the Eastern Region was working hard to see at least the southern part of the ECML turned over to the new traction during 1963, thus making many fine Pacifics redundant.

Many photographers of the time ignored the new forms of traction, treating them with disgust as they swept away many worthy steam types. For those of us who perhaps only started our spotting activities in the 1960s, we cannot recall the times before the arrival of the diesels. Indeed, today, with most of those early types themselves now swept aside, we recall those first sights of these new locomotives fresh from works with the same enthusiasm as we did back then.

To help bring back that nostalgia for the sixties we have picked up on various details from the time, whether they be musical, sporting, recreational, fashion, television, radio or news headlines to help us place those sixties spotting days once again. Looking back over fifty years, many of us cannot easily recall some of these facts without a prompt, those who attend quiz nights will back me up on this. But once we get going it all comes flooding back. It is with this hope, that you will enjoy the series in the same way, that I have enjoyed putting the books together. The series can go on as long as contributors keep coming forward to allow us the use of their colour slides and photographs from the era. Whether you have thousands or just a few from your spotting days, please make contact, as we will be pleased to discuss how perhaps you can share your photographic experiences with us all.

If you like this format, then join us for similar titles in the *Seventies Spotting Days* series as well. But for now settle down as we take this trip down memory lane to explore just a few locations within the area that once fell under the influence of the Eastern Region of British Railways during the 1960s.

Kevin Derrick
Boat of Garten

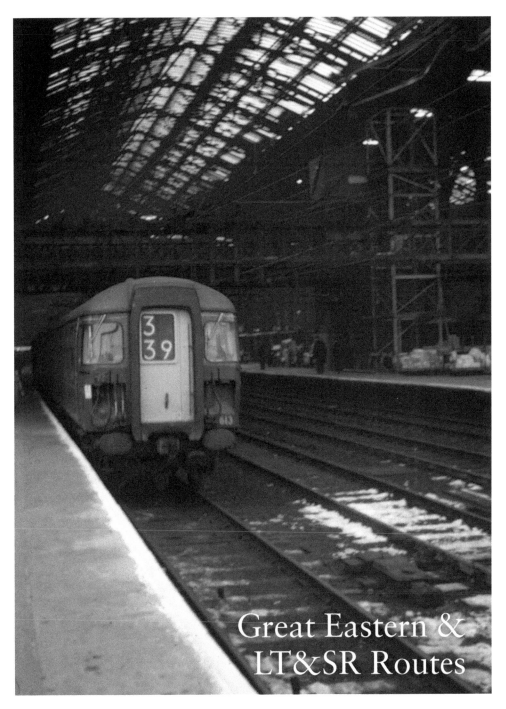

Great Eastern & LT&SR Routes

We start our journey around the region from the terminus of the Great Eastern Railway at Liverpool Street on a cold 10 January 1963. With the majority of services by the beginning of the 1960s in the hands of electric multiple units, perhaps the most glamorous of these units were for use on the Clacton and Walton services, unique in their maroon livery rather than the green which was the normal livery. As built, the units enjoyed a wrap-around windscreen and utilised the area around the corridor connections. It was to be later in January 1963 that the Beatles famously played at the Cavern, on the 30th and 31st. (Peter Coton)

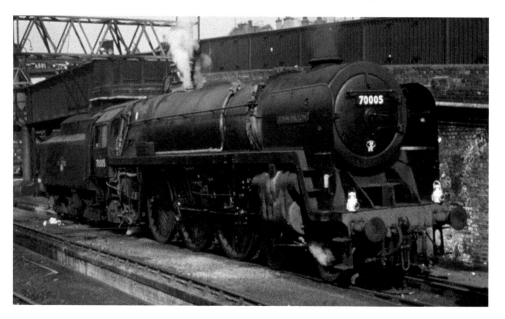

Britannia Pacifics had been drafted in to speed up the Norwich services almost ten years previously when new. This one, No. 70005 *John Milton*, had been sent to 30A Stratford from new and transferred to Norwich on 25 January 1959. When our cameraman caught the locomotive in the sun at Liverpool Street on 15 April 1961, the locomotive would have been working express turns along with English Electric Type 4s, but as deliveries of Type 3s from English Electric started, a move to 31B March ensued as of 10 September 1961. (Frank Hornby)

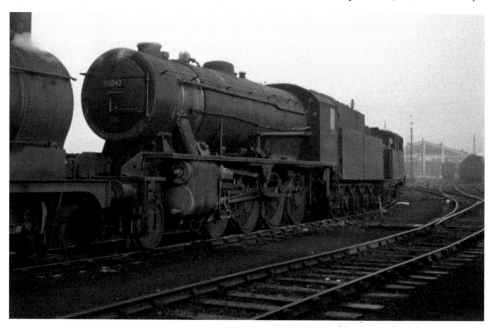

The new diesel facilities were already on the horizon when this visit to 30A Stratford took place on 17 January 1960. Steam was in fast retreat from the depot at this time, but an Austerity 2-8-0 No. 90042 was found among the many ex-Great Eastern Railway types still here. Right at the beginning of our spotting decade, Emile Ford and the Checkmates had enjoyed five weeks at the top spot of the charts with 'What Do You Want To Make Those Eyes At Me For'. (Frank Hornby)

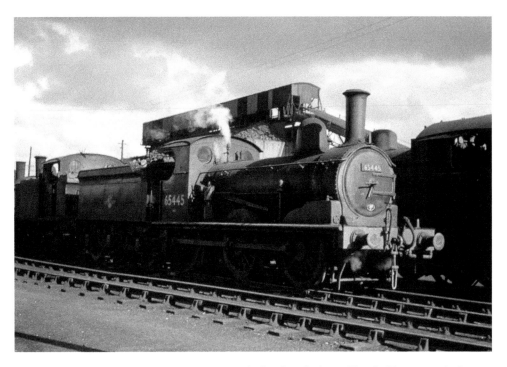

A year later and among the many locomotives on shed at Stratford was Class J15 No. 65445, which was a product of the works here in August 1899. This particular J15 would continue to work until August 1962. Like so many former Great Eastern Railway locomotives in the early 1960s, No. 65445 would be quickly cut up within the works at Stratford. (Vincent Heckford, Strathwood Library Collection)

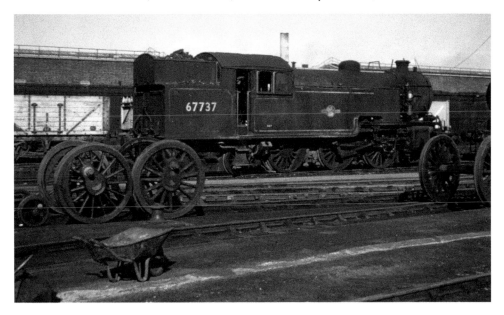

Going against this trend was Class L1 No. 67737, seen at Stratford in October 1961. Although this engine was based at 30A when withdrawn in August 1962, it moved all the way to Darlington Works, who engaged themselves in cutting up as many as seventy-nine of this class. As repairs had stopped why send the locomotives so far for scrapping? (Norman Browne, Strathwood Library Collection)

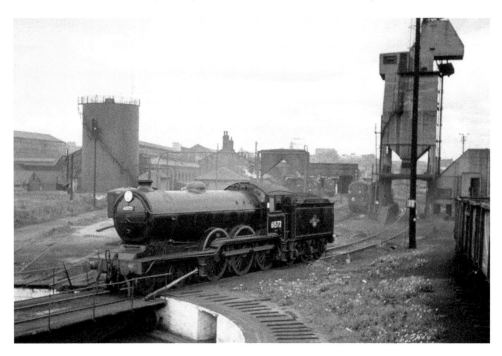

One locomotive that was to evade the scrapmen for many months after withdrawal was Class B12 No. 61572. It was the reluctance to send this locomotive on for scrapping after being taken out of service officially in September 1961 that allowed the preservationists time to organise themselves to raise funds and find a home to store the engine. However, in May 1961 the locomotive was due to work a school special to Swaffham and was going to be hand-coaled from a wagon by the turntable to ensure her paintwork did not get too dirty as would happen from the coaler in the background, where many of the newer diesels lurked. (Vincent Heckford, Strathwood Library Collection)

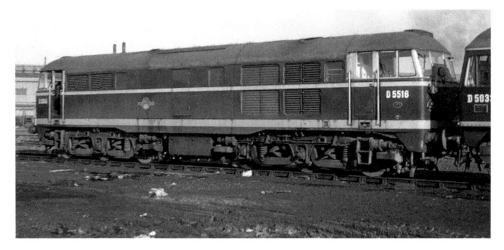

After years of small 0-6-0s being used for goods workings around East Anglia, the planners for the new diesel era thought that a range of Types 1 & 2 would give the best service. Hence these two specimens, one D5516 from Brush at Loughborough, originally with a Mirrlees engine and D5033, built by British Railways at Crewe with a Sulzer powerplant, were on shed at Stratford on 27 February 1960. The Brush product would spend all of its working life based at Stratford after receiving replacement engines from English Electric, while many of the Sulzer-engined locomotives would be drafted away quickly as the 1960s progressed. (Frank Hornby)

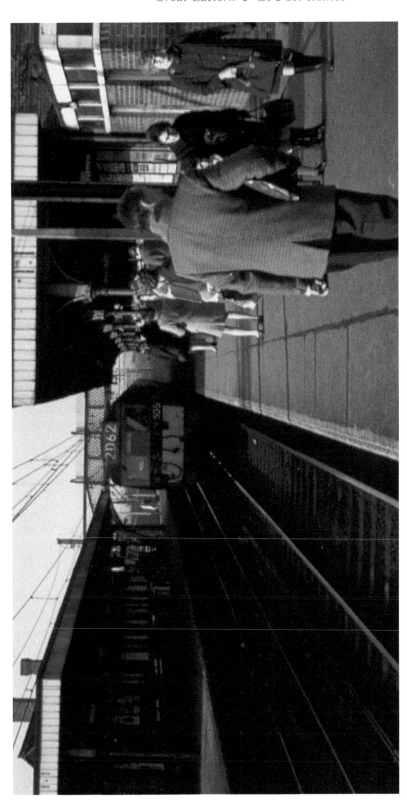

Here is a further reminder of the extensive use of electric multiple units that served some very busy suburban routes generating traffic levels that may have pleased the infamous Dr Beeching. One of the outer suburban units stops at Wickford on 18 November 1967. It is a pity now, perhaps, that so few of these operations were recorded in colour. On the Saturday when this photograph was taken, the Prime Minister of the day, Harold Wilson MP, made what was seen as a last-ditch attempt to save sterling and stabilise the economy by devaluing the pound by 14.3 per cent, reducing the exchange rate with the US Dollar to $2.40. It sounds a small matter today, but back then it was a momentous occasion. An occasion carefully underplayed by Harold Wilson, in his famous television broadcast: 'It does not mean that the pound here in Britain, in your pocket, in your purse or bank has been devalued.' (Derek Whitnell)

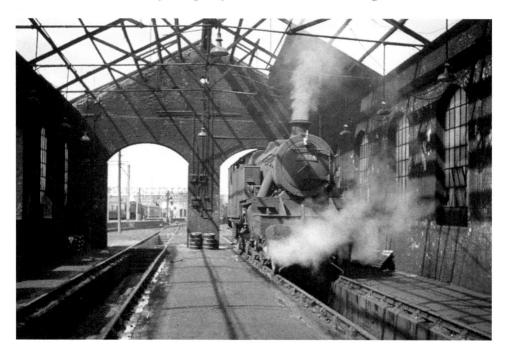

The bright and airy nature of the engine shed at 33C Shoeburyness on 15 April 1961 allows us a shot of one of the Stanier Three-Cylinder locomotives specially designed for the Southend and Thames estuary, No. 42504. This sub-class of thirty-seven engines was all built at Derby Works between April and December 1934. The first was taken out of traffic in December 1960 with the majority losing favour to replacement multiple units in June 1962. (Vincent Heckford, Strathwood Library Collection)

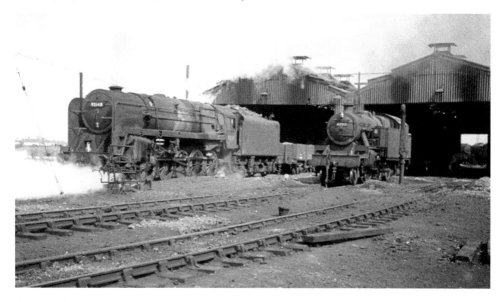

Another of the Stanier Three-Cylinder Class 4MTs, No. 42519, was on shed with Class 9F No. 92148 at 33B Tilbury. On the same day, the shed was also host to several other 4MTs and a number of Austerities. The shed here closed completely in September 1962, with the engines allocated being transferred to Stratford and the Standard 4MTs going to the Western Region for service on the Cambrian route.
(Vincent Heckford, Strathwood Library Collection)

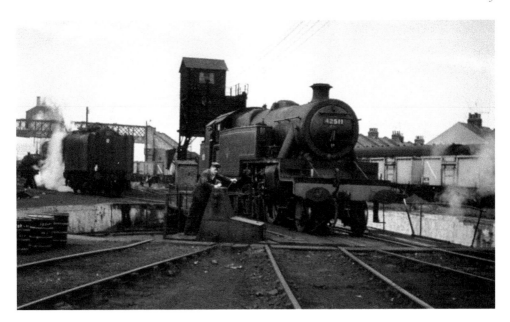

Shoeburyness shed closed completely on 18 June 1962. This visit, in the year before closure, highlights the busy nature of the depot servicing the locomotives off the services to London. Again one of the Stanier Three-Cylinder 4MTs No. 42511 was to be found among the locomotives on shed, as the driver watches his fireman get stuck into the hard work of turning this ninety-two-ton engine.
(Vincent Heckford, Strathwood Library Collection)

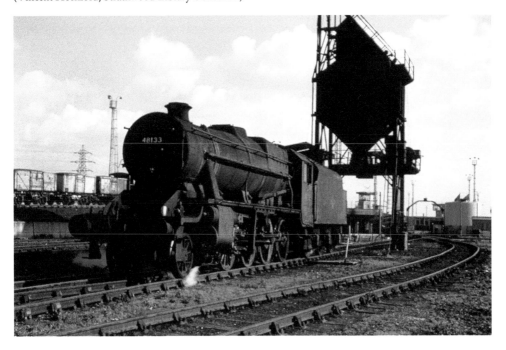

Servicing facilities were available for both steam and diesel at Temple Mills yard near Stratford, although little seems to be have been recorded of either. Stanier Class 8F No. 48133 has worked into the yard and has taken on a modest refill of coal for the return journey in this shot dating from 1961. The servicing point here was to close officially on 25 April 1966. (Vincent Heckford, Strathwood Library Collection)

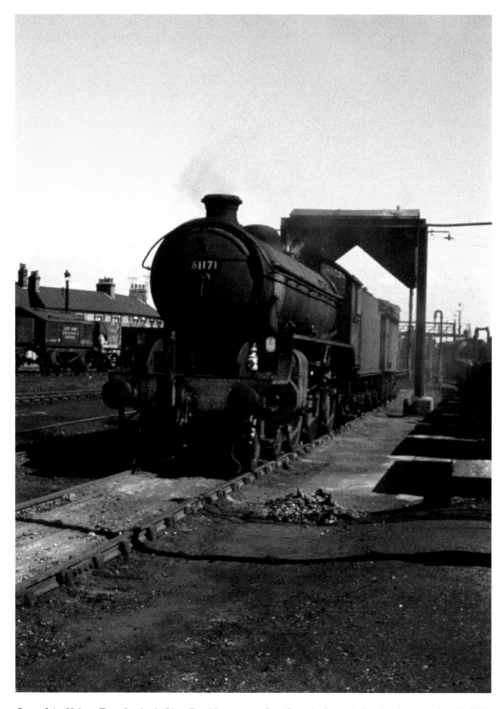

One of the Vulcan Foundry-built Class B1s, No. 61171, is found on shed at 31A Cambridge in early 1961. This was another location to close to steam on 18 June 1962. The pictured B1 would not fare much better being withdrawn from service in September 1962. Visitors to 31B March would have seen it stored there until May 1963, when a move to The Central Wagon Co. at Ince was effected around June 1963. The final cutting-up took place by the Christmas of 1963, ironically within a few short miles from where the locomotive was built in June 1947. (Alan Pike O.B.E)

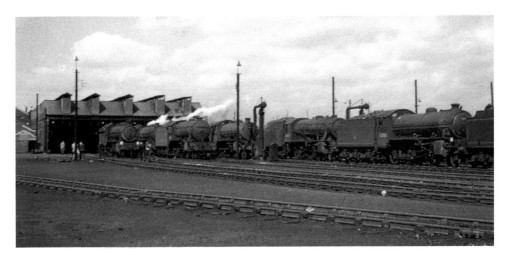

As a small party make their way around the engine sheds at 31B March on 18 April 1960, it is clear that the impact of the diesels now arriving every month and being reported within the periodicals of the time have yet to make their mark. The British Locomotive Shed Directory of the time stated just how easy it was to find the shed here; turn left outside the station and left over the level crossing. Turn first left into Norwood Road; a broad cinder path leads to the shed, walking time ten minutes. For enthusiasts visiting a location for the first time, directions, whether as simple as these for 31B March or those for visiting sheds such as 41D Canklow, where it was suggested walking time would be sixty minutes, were a great help and gave many a young spotter miles away from home the confidence to press on. (Frank Hornby)

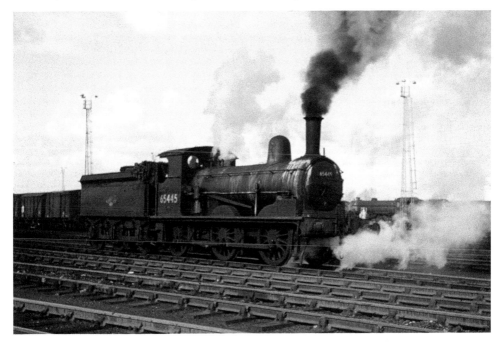

That same Class J15, No. 65445, which we saw at Stratford was seen again on 7 October 1961 in the busy yard at Temple Mills. Time was running out for these venerable 0-6-0s as only a handful remained in traffic at this time. If you were in the mood for the cinema at the time you may have gone to see *The Guns of Navarone* or perhaps *The Hustler*, starring a more youthful Paul Newman with Jackie Gleason, who had already made a name for himself on television. (Vincent Heckford, Strathwood Library Collection)

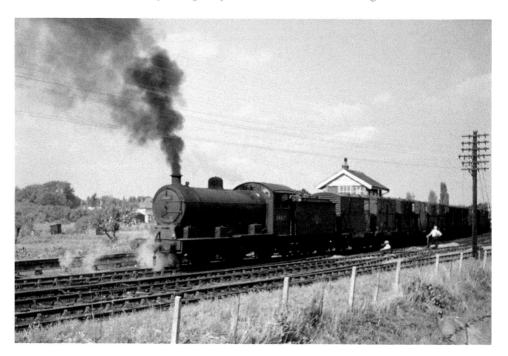

The permanent-way gang wear rolled up sleeves while working outside the signal box on the pointwork at Wisbech on 18 October 1961, as they watch the setting back of this goods. Another product from Stratford Works designed by Hill in original form and introduced to traffic in December 1922 was Class J20 No. 64690. This small class of twenty-five locomotives remained intact until November 1959. By the end of 1960 only thirteen remained on the books, with further scrapping taking place in 1961 leaving the last five to work into 1962, with this example being one of the last survivors in that September.
(Vincent Heckford, Strathwood Library Collection)

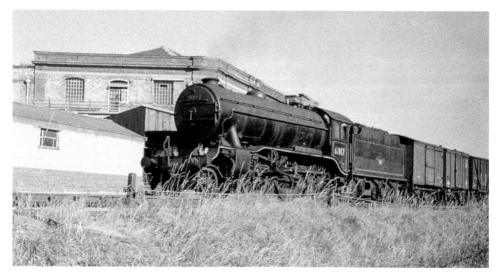

The Chivers factory at Histon is taking delivery of wagons headed by 31A Cambridge-allocated Class K3 No. 61817 on 30 August 1961. This was to become a 31B March-allocated engine that would be withdrawn three months before steam finished at the Fenland shed on 1 December 1963.
(Vincent Heckford, Strathwood Library Collection)

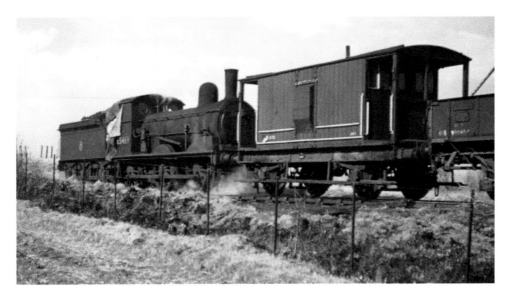

Track-recovery trains would become a familiar sight around the Fens in the sixties. In the earlier days they would be worked by steam as here by Class J15 No. 65469 at Acle on 16 February 1961. Sadly the late photographer did not leave us any notes as to where the track was recovered from, but we have surmised it was from the goods yard here. As the football season was progressing, supporters of Tottenham Hotspur were hoping that their run of form in both the league and the FA Cup would hold. When they reached the cup final against Leicester City, few would have argued that Spurs did not have the best team in the land at the time. In goal that day for Leicester was a young Gordon Banks, who would go on another day to have his moments of glory beneath Wembley's twin towers. It was to be the Spurs captain and Footballer of the Year Danny Blanchflower who would lead his team up to add the cup to the league title. (Vincent Heckford, Strathwood Library Collection)

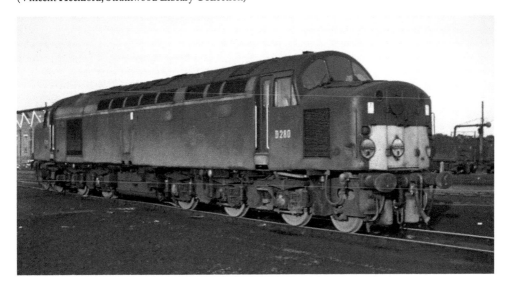

Steam continued to work into 31B March after it was closed officially and had lost its own allocation, as seen behind this view on 24 January 1965 with work-stained English Electric Type 4 D280. This locomotive had entered traffic on 17 June 1960 allocated to 52A Gateshead. It remained shedded to the Newcastle depot until February 1966. This one-hundred-and-thirty-three-ton leviathan was in the fifth batch of these locomotives to be delivered from The Vulcan Foundry. (Eric Sawford, Stewart Blencowe Collection)

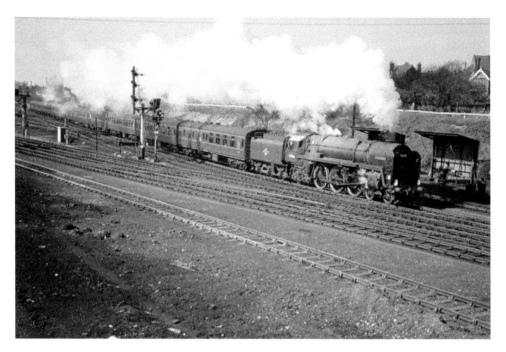

Britannia No. 70006 *Robert Burns* makes a rousing departure from Norwich on 10 April 1961. This was the home city for this engine at the time before a move to 31B March and later what would become a stronghold for the class at Kingmoor after 1963. The Beatles began a three-month residency at The Top Ten Club in Hamburg on this day. They played for seven hours a night on weekdays and eight hours a night on weekends with a fifteen-minute break every hour. (Vincent Heckford, Strathwood Library Collection)

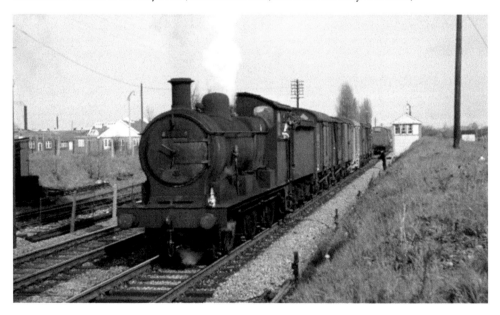

Meanwhile, in sleepy Sawston Class J17 No. 65582 was busy shunting its goods train by Sawston Sidings Signal Box. Eighty-nine of the class came into British Railways stock with just one withdrawn before 1948, LNER No. 8200, which perhaps would have become No. 65550 if it had not been hit by a German rocket in 1944. (Vincent Heckford, Strathwood Library Collection)

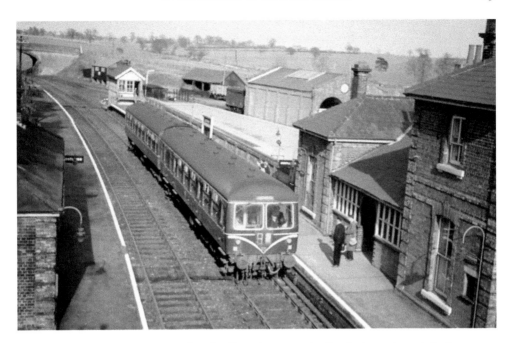

This pleasing view of the station and yard at Lavenham on 8 April 1961 shows the arrival of a two-car Cravens-built diesel multiple unit with a porter and several passengers for the service. Meanwhile in the background a study of the yard suggests there is still plenty of rail-borne traffic for the goods yard. Do not be fooled though, as we are only two days from closure to passengers, with the line closing completely to goods traffic from 19 April 1965. The change to diesel multiple units had been effected from 1 January 1959, but this lightly trafficked former Eastern Counties Railway section was doomed.
(Vincent Heckford, Strathwood Library Collection)

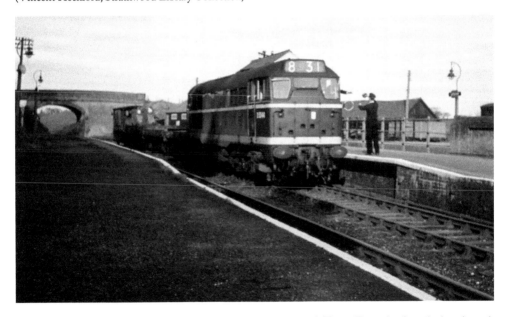

Here the porter-signalman exchanges tokens with the crew of Brush Type 2 D5544 heading the last through goods train, with evidence that at least some farm machinery was still being moved by rail on the same day.
(Vincent Heckford, Strathwood Library Collection)

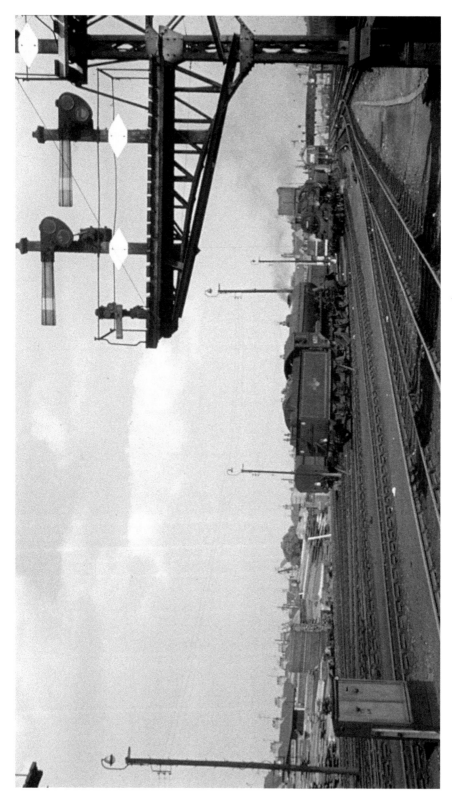

Framed by a delightful bracket arm supporting several signals at Cambridge, we find another Brush Type 2 together with a Gresley Class K3, No. 61801, and a British Railways Standard 4MT 2-6-0 shuffling about the yards by the station on 9 September 1961. John Leyton was extolling 'Johnny Remember Me' in the charts during September. (Alan Pike O.B.E)

Focus on Doncaster

New to our notebooks would be D6732, an English Electric Type 3 delivered in February 1962 and seen awaiting acceptance outside the works. It would seem that every time one visited this location in the early to mid-sixties something new would be on show here, possibly not yet in our most recent copy of the Ian Allan ABC. Acceptance for this engine would come with initial allocation to 50B Hull Dairycoates on 9 March 1962. (Strathwood Library Collection)

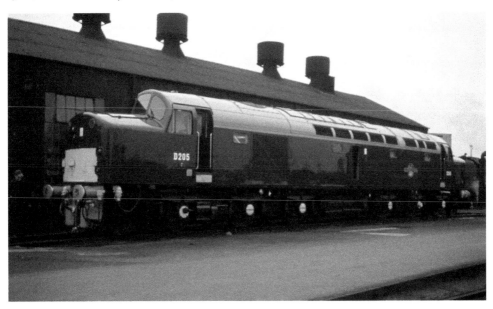

Having arrived for a works visit, English Electric Type 4 D205 is made ready for return to traffic around 1965 when still based at 30A Stratford. Some steam activity can be seen behind the locomotive, which would become a 32B-allocated machine in April 1966 before joining the ranks of its classmates on the London Midland Region from August 1967. (Strathwood Library Collection)

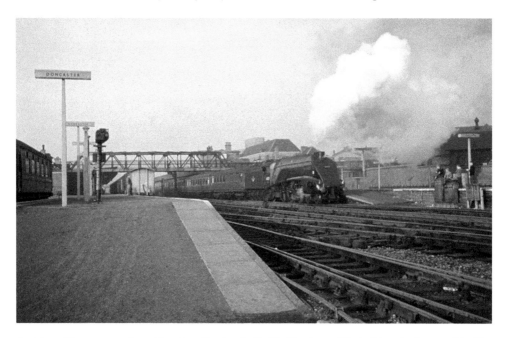

Activity at Doncaster station with a clean Gresley A4 Pacific No. 60029 *Woodcock* in 1961. As one of the Top Shed-allocated A4s, she would be nearly always be seen impeccably turned out, the double chimney having been fitted as late as October 1958. With the summer timetable of 1963 many of the Pacifics were withdrawn or transferred to other sheds, this one going to 34E New England for her last four months in traffic. (Strathwood Library Collection)

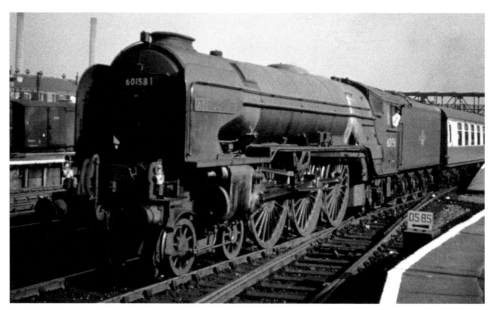

Getting away from a stop at Doncaster in early 1960 was Class A1 No. 60158 *Aberdonian* with The West Riding. This locomotive was shedded at 36A Doncaster from October 1958 until being taken out of service in December 1964. In spite of the engine being stored at the shed here, it was not to pass into the works for breaking up. Instead it was sold to scrap-dealers Hughes Bolckows in Blyth, who duly dealt with their one-hundred-and-four-ton purchase by April 1965. (Trans Pennine Publishing)

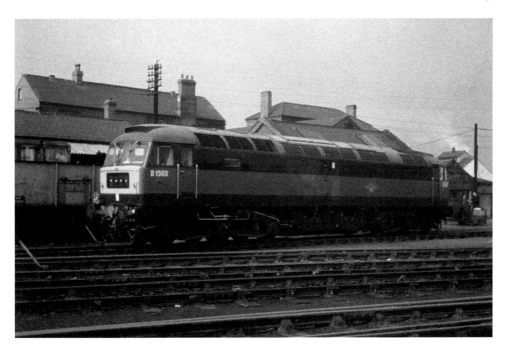

It was the steady arrival of Brush Type 4s to the Eastern Region that was killing off more and more of the top-link locomotives, although when this 1963 view was taken, the doyen of the class D1500 had been in traffic since 29 September 1962. She had obviously come back to the works here for some attention before being re-allocated from 34G Finsbury Park to 41A Tinsley in October 1963. (Strathwood Library Collection)

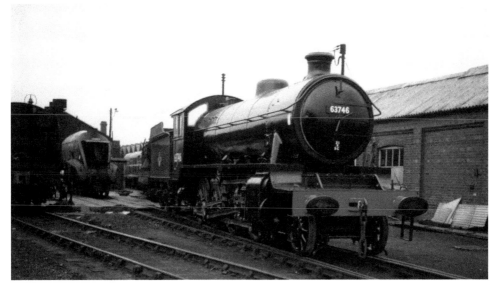

We think this shot of Class O4/4 No. 63746 dates from May 1962 as it is ex-works, ready for return to traffic at 31B March. This engine was constructed by the North British Locomotive Company in October 1917 as part of the war effort for the Railway Operating Division. Some 521 engines were built by various workshops between 1917 and 1919. At the end of hostilities, many were sold off by the government very economically, with examples being snapped up by various railways as far afield as Australia and China. (Vincent Heckford, Strathwood Library Collection)

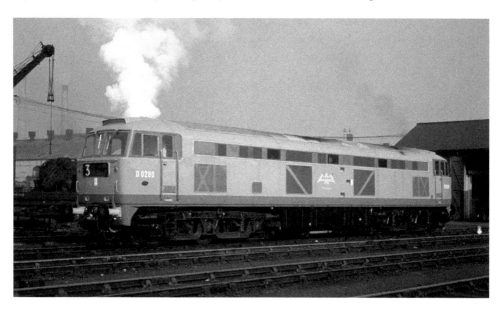

As the prototype for a lightweight Type 4 design, Brush D0280 *Falcon* certainly achieved the makers' objective in winning the British Railways main order for this power classification. It won perhaps on false grounds, as at the time of construction no suitable 2,800-hp power unit was available, so two 1,440-hp units from Maybach were substituted instead. *Falcon* arrived on the Eastern Region on 13 October 1961, firstly to 34G Finsbury Park before going to 30A Stratford for November 1961. It will be noticed that inside the shed in this view is a brand-new BRC&W Type 2 as yet to gain yellow warning panels. We can therefore assume that this shot was taken between the locomotive's introduction and the end of October 1961 when on test from 34G. (Strathwood Library Collection)

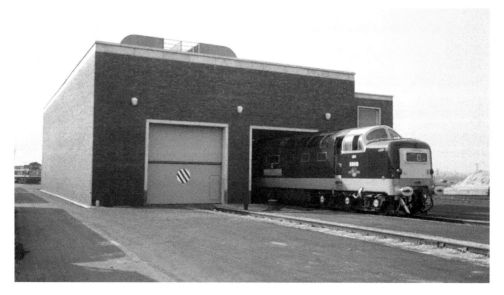

Completely new testing facilities were built at Doncaster, specifically for the benefit of the Deltics but used by a wide range of classes through the years. Just prior to being named in a ceremony at Glasgow Central on 11 September 1965, English Electric type 5 Deltic D9019 *Royal Highland Fusilier* was recorded undergoing tests. While a Brush Type 2 lurked in the background, no visit to Doncaster Works would be complete without seeing at least one of these right into the 1990s. (Strathwood Library Collection)

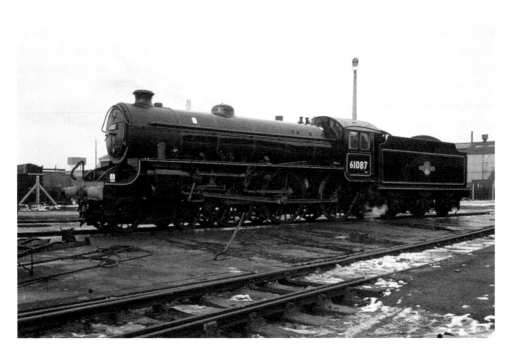

Outshopped from the works into the snow of January 1963 was Class B1 No. 61087, which was another long-term resident of 36A. This trip through the works was likely to be the last for the engine as it succumbed to withdrawal in December 1965. By this time policy dictated that most locomotives were sold to outside scrap-dealers rather than broken within British Railway workshops, hence this 'Bongo' was sold to Garnham, Harris and Elton at Chesterfield for their attention in June 1966. (Strathwood Library Collection)

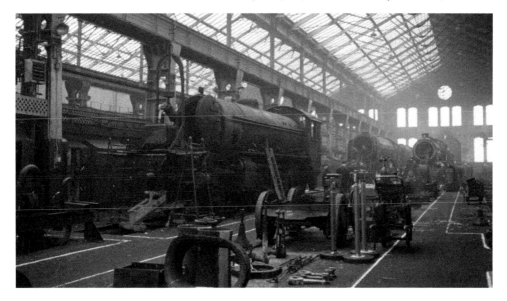

Photographs inside the works were hard to obtain, especially in colour, due to the limitations of the slow speed of the film of the day. However, this unknown cameraman has served us well with this view inside the shops depicting Class K1 No. 62058 and, in the background, what appears to be an A1 Pacific and a B1 by its side. It can be assumed that this was taken around the summer of 1963 just before the K1 moved from 51A Darlington to 50A York. (Strathwood Library Collection)

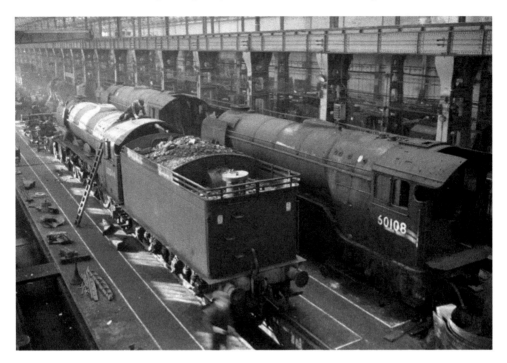

Both of the Gresley Class A3s No. 60044 *Melton* and No. 60108 *Gay Crusader* appear to be undergoing repairs and as they were both to come out of traffic in the early autumn of 1963, we would suggest this view is from 1961. (Strathwood Library Collection)

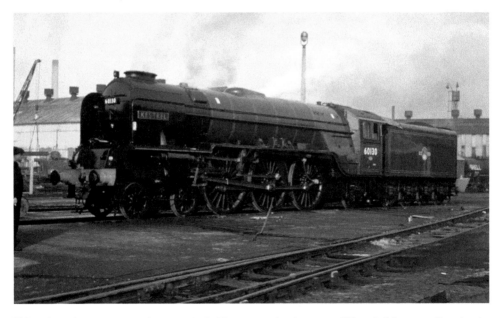

Taken about the same time as the ex-works B1 No. 61087 is this fine view of Class A1 No. 60130 *Kestrel* as the snow lies on the ground during that harsh winter of 1963. This superb Pacific would continue at its last base of 56B Ardsley, before sale to one of the smaller scrap merchants of the time: W. George Ltd of Wath-on-Dearne in October 1965. Meanwhile, down in London The Who were recording 'My Generation', which went to number two in the charts. (Strathwood Library Collection)

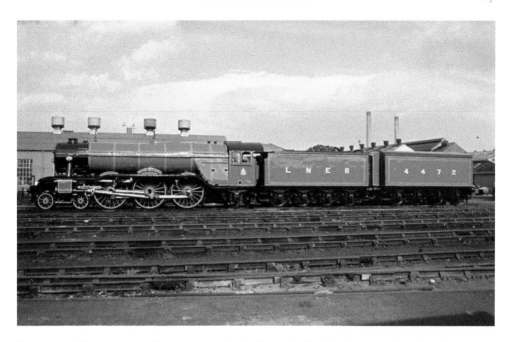

During 1966, No. 4472 *Flying Scotsman* entered the plant to be fitted with a second tender in response to operational difficulties, as obtaining water during tours was getting more difficult due to infrastructure being removed around the regions. The locomotive's saviour, Alan Peglar, added an adapted corridor tender with a capacity of an additional 6,000 gallons. By the time of the next overhaul in 1968, it had to be carried out by Hunslet (Leeds), because Doncaster was no longer able to overhaul steam locomotives. (Strathwood Library Collection)

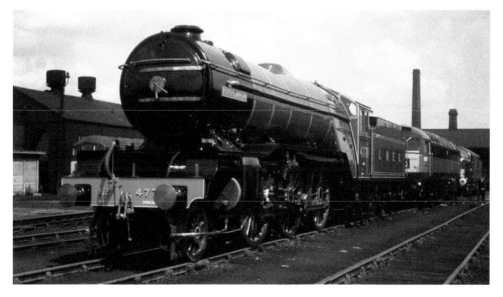

During 1963, the now-withdrawn No. 60800 *Green Arrow* was restored as No. 4771 in LNER livery for inclusion within what was planned as the new Leicester Municipal Museum. This was never to come to fruition, but it did mean that the locomotive was saved for posterity and has now found itself in the care of the National Railway Museum. As can be seen in this shot from 1963, further new locomotives from Brush and English Electric were arriving and a Sulzer Type 2 was on works behind for servicing. (Strathwood Library Collection)

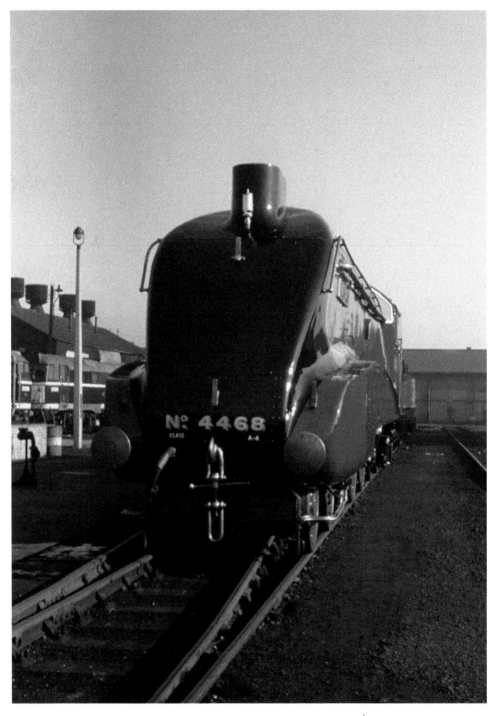

Preservation surely had to come for No. 60022 *Mallard* upon withdrawal in January 1963. Sure enough, this historic engine was restored to the condition in which she had completed her historic feat pre-war. Restoration completed, the locomotive was to spend the remainder of the decade inside the British Museum of Transport at Clapham, inside what was originally an old London County Council Tram Depot. (Strathwood Library Collection)

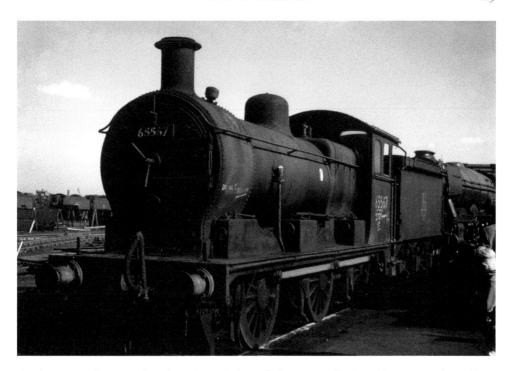

Another engine that was to have been destined also to find its way to Clapham Museum was the ex-Great Eastern Railway Class J17 No. 65567. However, in the event, after restoration the engine was stored variously at Stratford, Stewarts Lane and Preston Park before going on display at Bressingham. When seen here at Doncaster in 1963 it was most likely a cop for these spotters going around the works yard. (Richard Sinclair Collection)

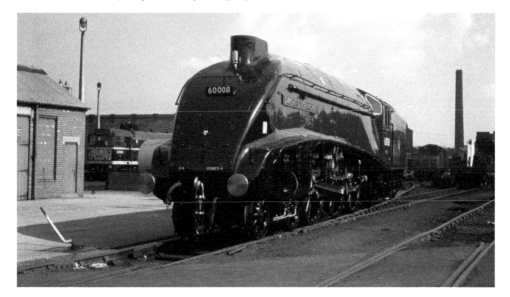

Continuing with our restoration and preservation theme at Doncaster in the sixties, we find A4 Pacific No. 60008 *Dwight D. Eisenhower* moved out into the sunshine for a photographic opportunity in March 1964. In the background, in those carefree days before risk assessments and more regulations than you could have ever imagined in the sixties, several fitters enjoy the spring sun as they work on the roof of a Brush Type 2. (Strathwood Library Collection)

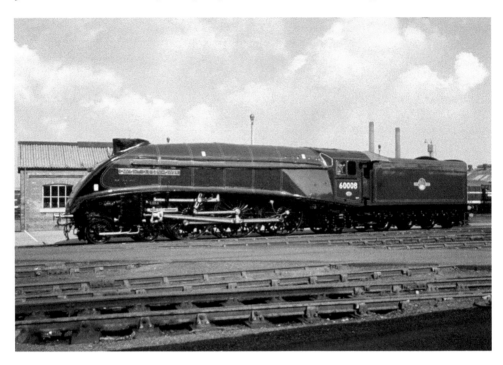

A second shot of this perhaps fortunate A4 No. 60008 *Dwight D. Eisenhower* has been selected to show the quality of the finish applied to locomotives leaving the plant. It also serves as a comparison of styles of Pacific against the once-streamlined design of Sir William Stanier FRS seen below. (Strathwood Library Collection)

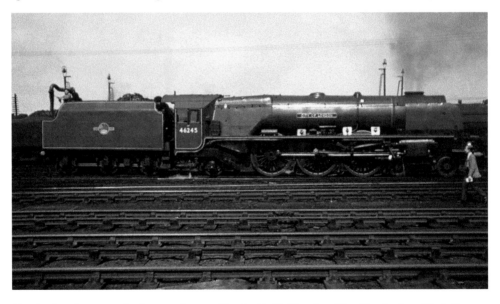

Creating huge interest at the time was the run of Stanier Pacific No. 46245 *City of London* from King's Cross to Doncaster on 9 June 1963. Various un-authenticated speeds have been claimed from the return run of this special descending Stoke Bank towards Peterborough, with one as high as 118mph. Certainly a fast run was made, but nothing has supported these claims. Our cameraman was one of many to be out on the lineside this day to photograph the spectacle. This view was taken during the break at Doncaster for preparing the engine for the return run. (John Rowe)

The fireman takes it easy as this unidentified and typically filthy 'Dub Dee' does a turn on the 36A Doncaster turntable in July 1964. This was the month in which The Rolling Stones appeared on Juke Box Jury and was the only time the panel was made up of five rather than four. Also this month, The Beatles' first film *A Hard Day's Night* premiered in London. (Strathwood Library Collection)

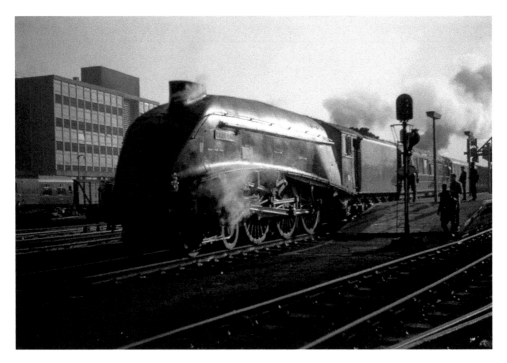

The departure of a Pacific from Doncaster would often gather a few spotters to witness the spectacle close up. Those distinctive lines catch the winter sunshine in this cracking view of A4 No. 60025 *Falcon* in 1961. (John Rowe)

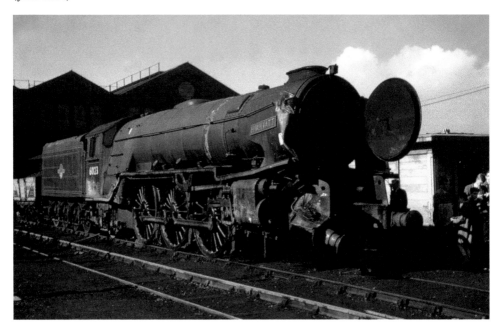

Enthusiasts examine the somewhat modified lines of Class A1 No. 60123 *H.A. Ivatt* in October 1962. The locomotive had been involved in an accident at Offord a few weeks previously in September. Repairs were not forthcoming for this unfortunate thirteen-year-old engine and the breaking up took place very quickly during the same month of this photograph within the works. (Richard Sinclair Collection)

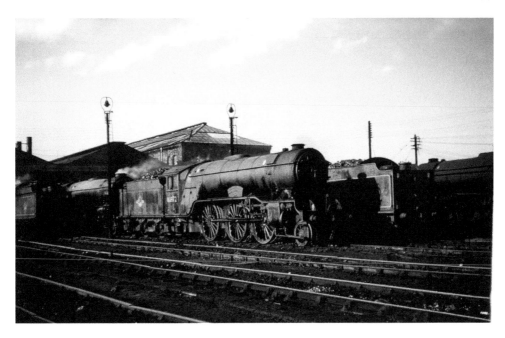

One of the named Gresley Class V2 locomotives was No. 60872 *King's Own Yorkshire Light Infantry*. The name linked Doncaster with the regiment and these nameplates were removed in early 1963 from the V2 and new plates cast for the naming of the Deltic D9002 that took on the name in a ceremony at York station on 4 April 1963. The V2 soldiered on until September when it was ushered into the works for the scrappers to do their work. (John Rowe)

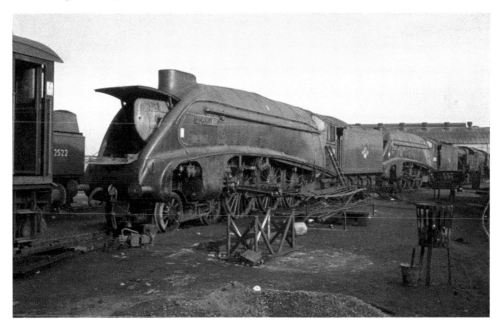

The cutting-up area of the works was to see much action during the sixties. In this line up a spotter might be wondering what would happen to the nameplates of this pair of A4s, whereas the fate of a pair of Stanier 4MTs and a K3 will be inevitable. Just in frame on the left is the cab of No. 15004, an LNER one-off diesel shunter that also met its demise with rather more elegant locomotives. (Strathwood Library Collection)

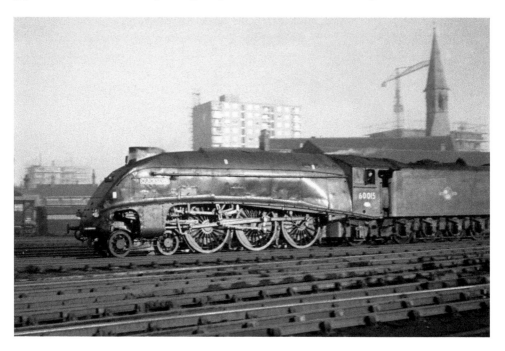

Catching the winter sun is another Class A4 during its last month of service, No. 60015 *Quicksilver* in January 1963. The LNER publicity department hit just the right note with the public's imagination in 1935 when the first group of four A4s went into traffic with splendid silver-inspired paint jobs and names for service on The Silver Jubilee high-speed train. (Strathwood Library Collection)

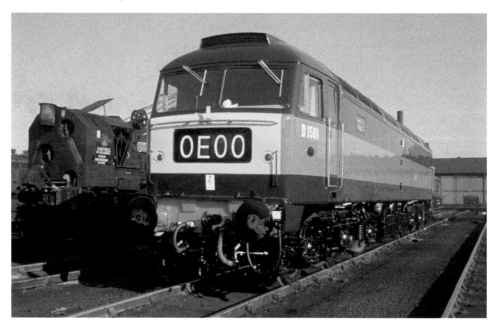

Fitters work on the steam crane in the background in early November 1962 while our photographer concentrates on the second-built Brush Type 4 D1501 which has recently arrived from the makers' works at Loughborough. It entered service officially on 13 November based at 34G Finsbury Park, with crew training on this new class of locomotive taking place from 34E New England shortly after. (Strathwood Library Collection)

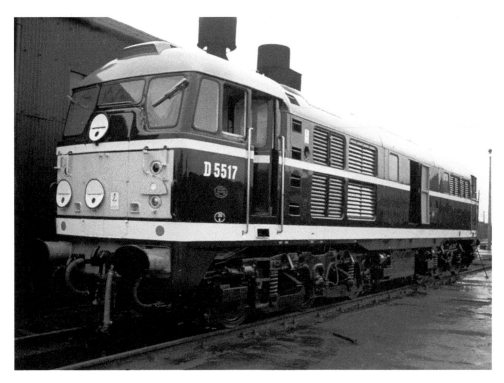

Routine overhauls were bringing photographic opportunities for ex-paint-shop locomotives on every visit to Doncaster of course. This time we catch one of the Brush Type 2 locomotives fitted with a Mirrlees 1,250-hp engine. Although these power plants had performed well at first, they were starting to show signs of fatigue by 1964, which would lead to replacement with power plants from English Electric being considered. (Strathwood Library Collection)

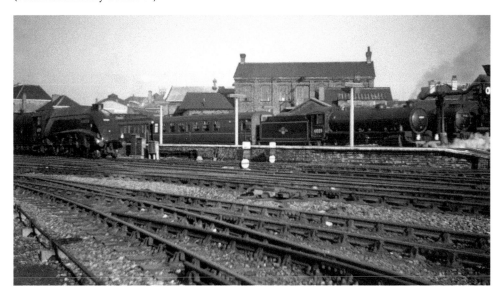

A busy moment at the station in 1961, with A4 No. 60029 *Woodcock* arriving and Class A1 No. 60156 *Great Central* in the bay along with Class B1 No. 61089, which has an interesting clerestory coach in its formation. (John Rowe)

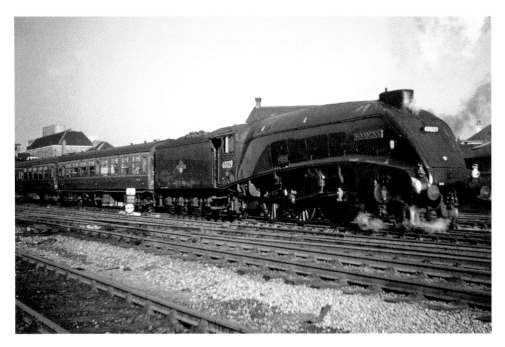

The occupants of the other platforms had cleared by the time Class A4 No. 60029 *Woodcock* was making her departure. Another Class A4 4489, which became No. 60010 in British Railways days, was originally given the name of *Woodcock* and then renamed as *Dominion of Canada* in June 1937. (John Rowe)

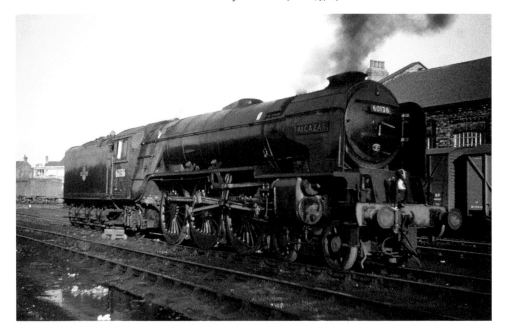

In the roll as standby locomotive in case of failure or poor running on the ECML from Doncaster was Class A1 No. 60136 *Alcazar* on this occasion. Having been built during the early months of British Railways this A1 was released to traffic on 26 November 1948, running without a name for the first two years. The name of the winning horse of the 1934 Doncaster Cup was applied on 8 December 1950. By the time of this picture in 1961 only another couple of years of use would be ahead for this magnificent locomotive. (John Rowe)

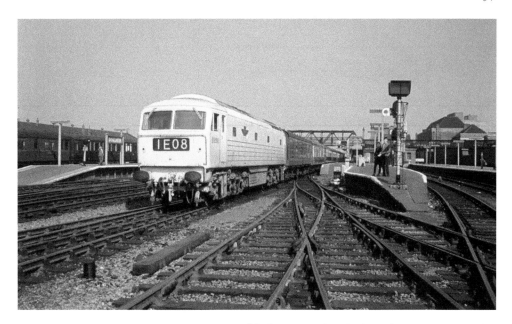

Another short British Railways career was to befall the Birmingham Railway Carriage & Wagon Co. prototype D0260 Lion. We find this impressive locomotive being watched by just a couple of spotters (it must be a weekday) on departure from Doncaster with the Sheffield Pullman in September 1962. It was returned to the makers in October 1963 after just eighteen months on loan to British Railways. It was dismantled around March 1965 with the shell being seen in the scrapyard of T. W. Ward at Beighton for cutting up. (Strathwood Library Collection)

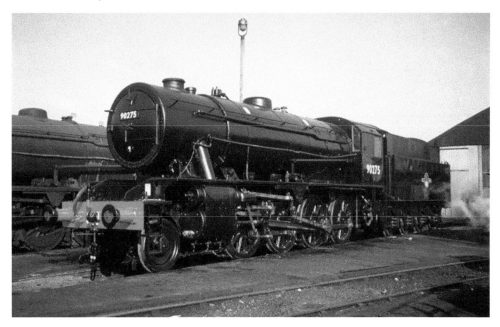

This humble 'Dub Dee' seen ex-works in January 1963 gave much more valuable service. During this engine's war service when numbered No. 77394 from November 1943, it went across to work from Tournai in Belgium from February 1945, returning to the UK by December 1948 and taking up the British Railways number No. 90275 in August 1949. (Strathwood Library Collection)

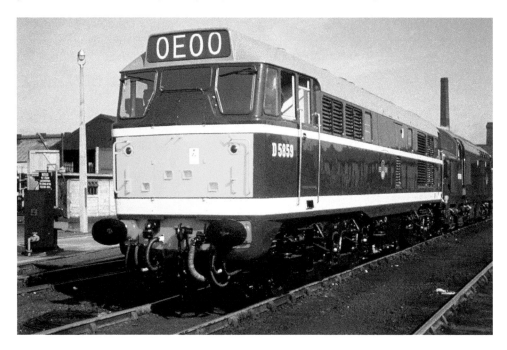

Wearing the usual delivery headcode from the Brush works at Loughborough is D5859 in September 1962, while awaiting acceptance tests. Behind the Brush product at the same time is an English Electric Type 3, which has returned for remedial work. (Strathwood Library Collection)

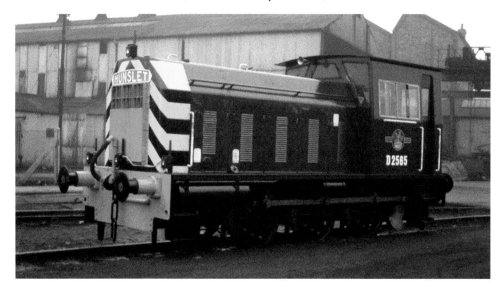

Often ignored by cameramen were the various early types of diesel shunter, such as this example from Hunslet. These engines were less than successful; this one has just been repainted from black livery as originally delivered with the number 11168. Sent first of all to work out of 32A Norwich when introduced in June 1957, by March 1963 and this overhaul, the writing was perhaps on the wall. Transferred away from the Eastern Region to the London Midland at 8F Springs Branch Wigan in February 1966, little work would be found for this machine and inevitably it was taken out of traffic officially as of 25 March 1967. It would be hauled back to the fringes of Eastern Region territory for breaking up by C. F. Booth in Rotherham during March 1968. (Strathwood Library Collection)

A reminder that Doncaster Works built several types of electric locomotive including the London Midland Region's flagship class of AL6 for the West Coast Main Line. One of these, E3140, was seen outside the workshops awaiting delivery in March 1966. Adorned with the older style of crest and dressed in the more pastel version of electric blue of this bright new style of railway that had been heralded by the subtle name change from British Railways to British Rail from January 1965. (Strathwood Library Collection)

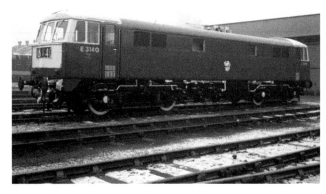

Also taken in 1966 was this shot of one of the D. Wickham & Co. diesel multiple units, which was converted for use as an inspection saloon. It is painted in the same shade of blue but has cast alloy Inter-City arrows fitted. Inside the saloon it was decked out in what was considered the height of modernity and good design taste, tangerine orange vinyl! Perhaps very chic then, but most likely uncomfortable in nylon clothes on a hot day. (Strathwood Library Collection)

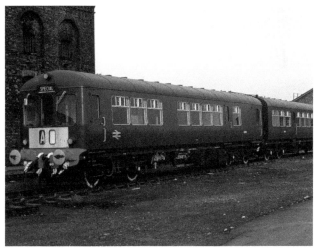

One of the first diesel multiple unit vehicles to receive the recognised new corporate blue-and-grey livery was this driving composite from a Trans-Pennine unit. With evidence of a shiny green DMU carriage in the background, it was no surprise that many units would be in mixed liveries until the end of the decade. (Strathwood Library Collection)

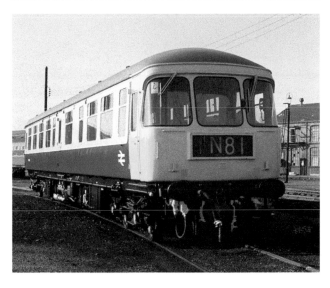

South Yorkshire and
the East Midlands

Electric passenger services would continue to run until 5 January 1970 across the Pennines from Manchester Piccadilly to Sheffield Victoria. This snowy scene is from the last winter of service in 1969, with E26052 *Nestor* arriving at Penistone. (Len Smith)

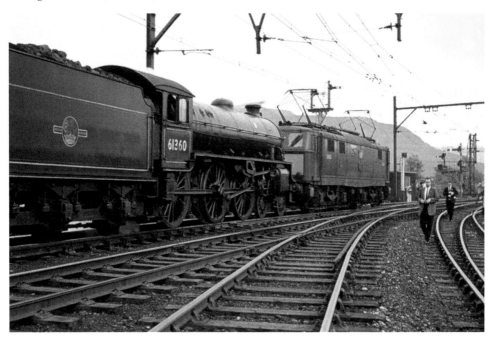

The first-built of the Woodhead electrics was No. 26000 *Tommy*, which was used as a pilot to Class B1 No. 61360 at Wombwell Main Junction for the run through the tunnel to Guide Bridge on 27 June 1964 with the RCTS High Peak Railtour. (Trans Pennine Publishing)

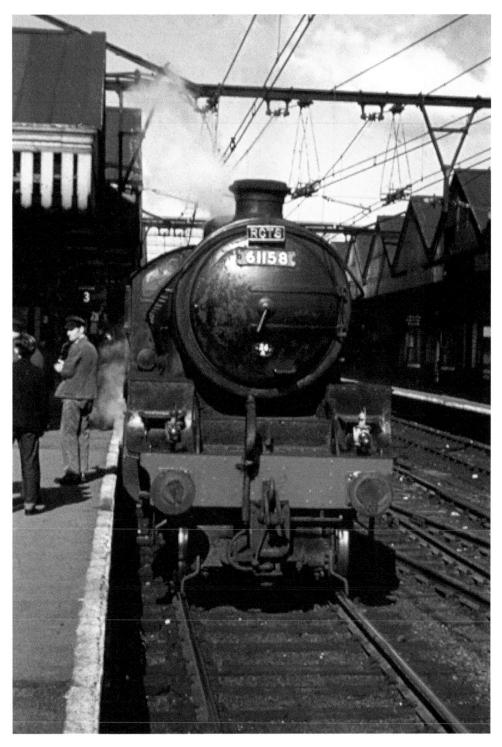

Another RCTS special headed by a Class B1 No. 61158 was at Sheffield Victoria on 29 August 1964. This was ten years after the station was originally electrified which brought the journey time between the Steel City and Manchester to just fifty-six minutes. (Strathwood Library Collection)

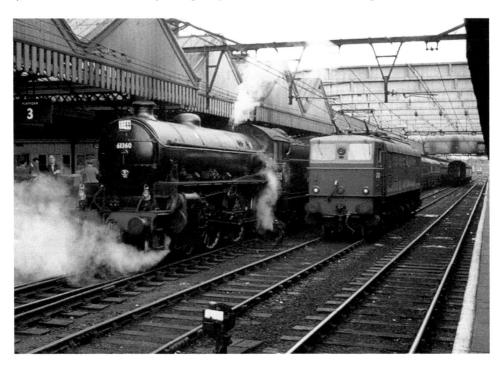

The start of that earlier High Peaks Railtour was also from Sheffield Victoria station on 27 June 1964 with Class B1 No. 61360 at the head. Alongside, in the centre road, was No. 27002 *Aurora*, one of the EM2 Co-Co electric locomotives favoured for the express passenger turns over the route, whilst in the distance one of the EM1 Bo-Bo locomotives awaits developments. (Trans Pennine Publishing)

Mixed motive power was the focus of attention for some more spotters at Sheffield Midland in the same year. Ivatt Class 2MT No. 46465 is in the bay while one of the Peak diesels, D74, based from 14B Cricklewood West is actually on a London Midland Region train that has come up from the south. (Trans Pennine Publishing)

Staying at Sheffield Midland, a pair of Class B1s is engaged on station pilot duties in October 1964. The Eastern Region favoured the use of carriage-heating locomotives, and upon withdrawal in February 1966, No. 61315 took on just such a role, being numbered in the Departmental series as No. 32. It missed out on preservation after its useful days were over in June 1968, when it was sent from Barrow Hill to Hesselwood scrapyard at Attercliffe for disposal. (Win Wall, Strathwood Library Collection)

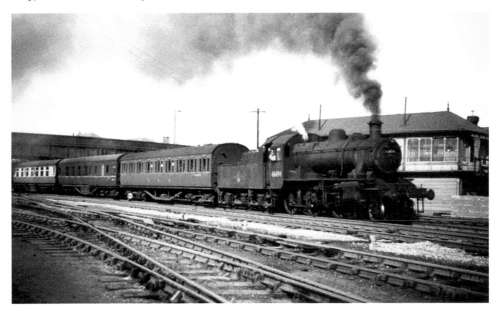

Another of the Ivatt moguls, which were often to be found around this area, is seen at Rotherham in 1960. Based at this time at 41C Sheffield Millhouses shed, No. 46494 was to have a short existence in the sixties. Transferring to East Anglia just as steam was finishing, it found itself being withdrawn in October 1962 and cut up straightaway at Crewe Works, giving this little engine a working life of barely eleven years. (Trans Pennine Publishing)

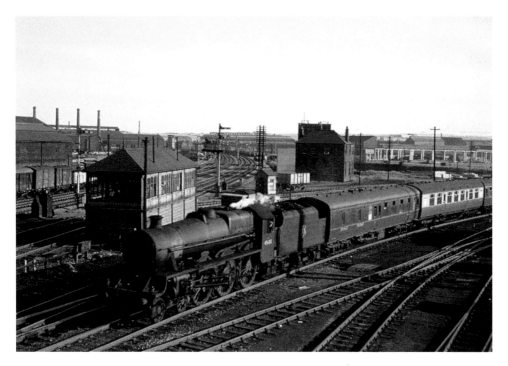

Once again we see Rotherham at the beginning of our decade with the arrival of Jubilee No. 45683 *Hogue*. This interesting name came from the Naval Battle Honour, which took place off the French Coast, under the command of Admiral Rooke from 19 to 23 May 1692. I would venture that very few spotters would have been aware of that little titbit when they read the name in their Ian Allan ABCs. (Trans Pennine Publishing)

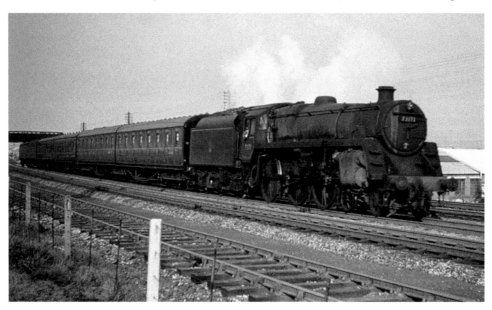

Our last view from the Rotherham area in the very early 1960s shows Standard Class 5MT No. 73171 from 55A Holbeck looking very work-stained with a stopping service made up of articulated coaches. We will see this engine again in a volume on the Southern Region where the locomotive ended her days. (Trans Pennine Publishing)

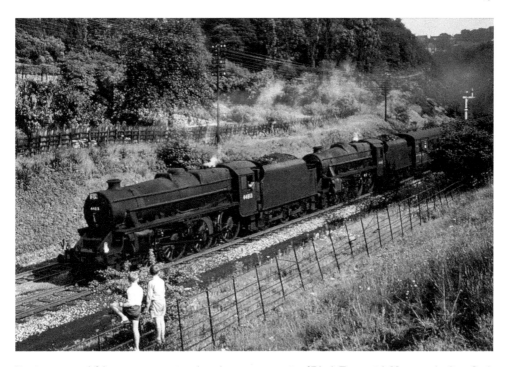

Passing our youthful two spotters going the other way are a pair of Black Fives, with No. 44813 leading. Such a happy scene would only last for few more summers in the 1960s, as diesels would take over more and more services, including summer extras such as this train. (Trans Pennine Publishing)

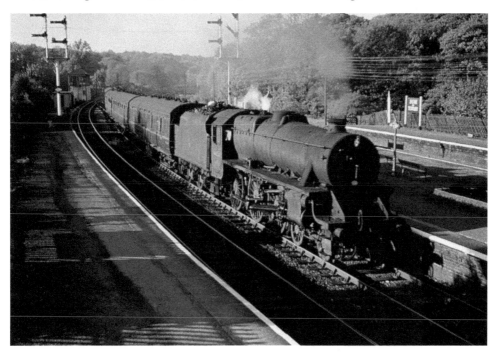

Back at the station, which carries Eastern Region blue enamel signage, another Black Five, No. 44855, appears to be running through without stopping in this view from 1961. (Trans Pennine Publishing)

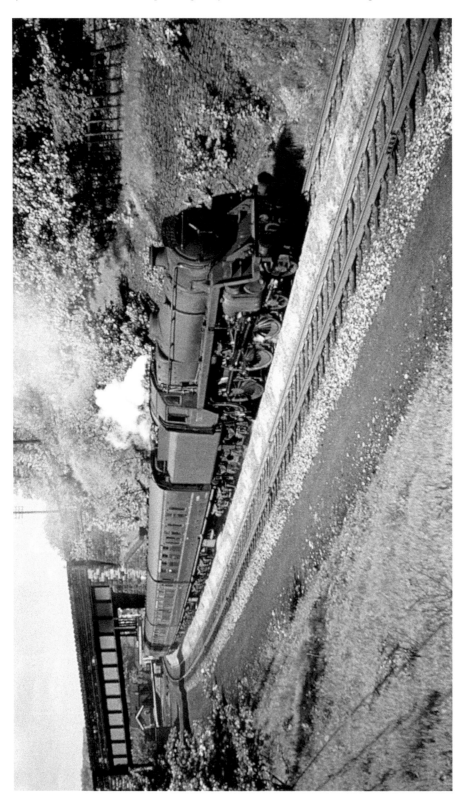

The locations around Dore & Totley have become familiar to us all through the work of several celebrated Sheffield-based cameramen. In the summer of 1960 another Standard Class 5MT is seen coming around the curves at this location, where both the Eastern Region and the London Midland Region territories met. (Trans Pennine Publishing)

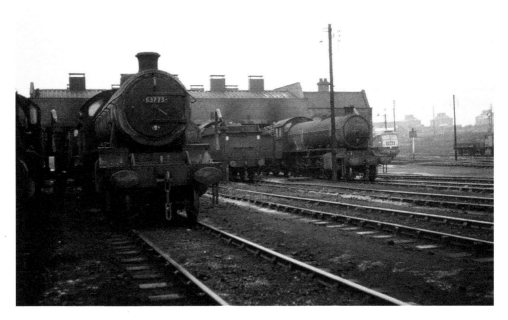

A Brush Type 4 invades the domain of clanking Eastern Region 2-8-os at 41H Staveley Great Central shed in April 1964. Another winter would come and go before the shed here would finally close on 14 June 1965. The Class O4/4 No. 63773 would not make it until the end for this location, dropping out of service in October 1964 and being cut up locally at Ward's yard at Killamarsh in February of the last year of steam here. When our photographer took this view, a new television channel was just starting: BBC2, with the very first programme being *Play School* at 11.00 a.m. every weekday morning. (Win Wall, Strathwood Library Collection)

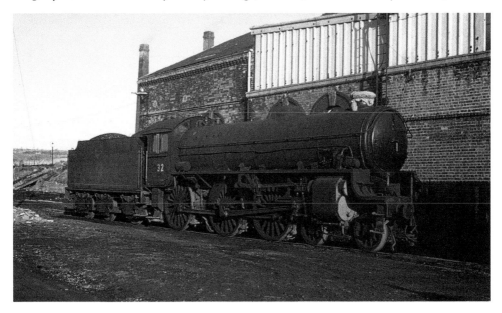

We have already described how Class B1 No. 61315 became No.32, and now we find the locomotive neatly stored out of use on 29 January 1968 also at Staveley. Adding to the longer term programming for the BBC, *Gardeners' World* had now started during this month, bringing us a famous horticultural name from the decade: Percy Thrower. (Strathwood Library Collection)

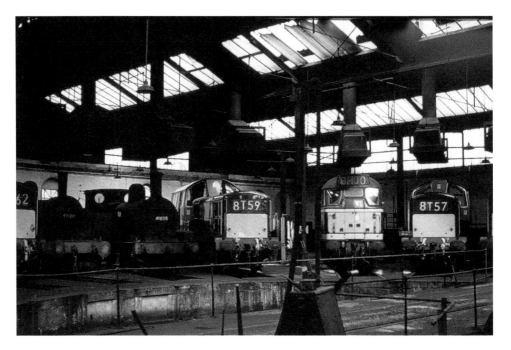

The thoughts of preservationists making the roundhouse at 41E Barrow Hill into the sanctuary for steam and diesel locomotives we enjoy today would have been met with derision back in 1965 when our cameraman took this photograph of four Clayton diesels awaiting delivery, a Brush Type 2 and a couple of the now-redundant steam shunters from the nearby Staveley Iron works inside the still-active shed. (Noel Marrison)

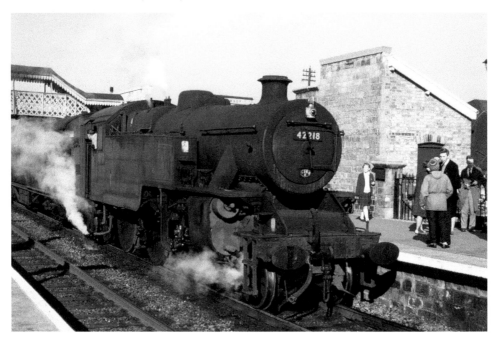

Seen at Worksop with a stopping service for Nottingham was Fairburn 4MT No. 42218 on a wonderfully sunny spring day during 1963. This was the first year that Scottish motor racing legend Jim Clark was to become World Motor Racing Champion, driving for Lotus. (John Rowe)

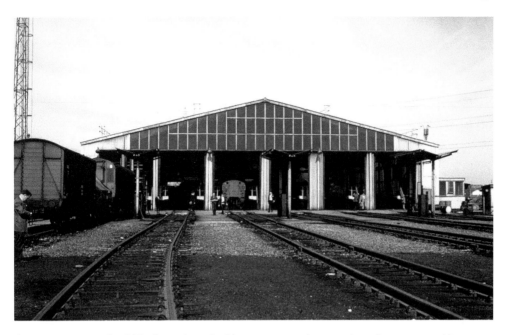

A society visit around 41A Tinsley at the end of the sixties on 24 August 1969, and most respectable spotters were still to be found favouring a tweed jacket and tie as the dress code while they enjoyed their hobby. The front of the depot seems remarkably quiet in this view of the main shed building, which opened, along with the depot, on 26 April 1964. (Frank Hornby)

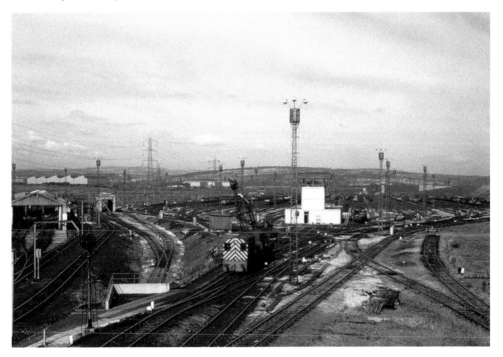

Looking out from the bridge leading to the depot towards the vast marshalling yard and the small servicing shed on this same visit, we see one of the depot's hump shunters in action with the breakdown crane. (Frank Hornby)

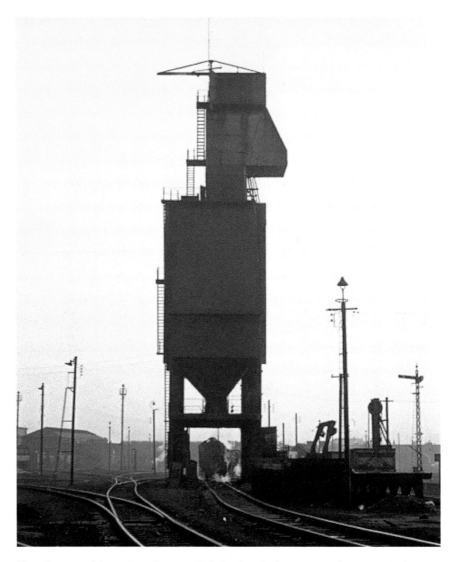

The silhouette of the coaling plant at 40E Colwick ends this section in January 1966, the same month as another of those boundary changes saw the depot become 16B within the London Midland Region. The depot was closed officially to steam on 12 December 1966 and completely in February 1967. A reprieve saw it re-open during June 1967 for just over a month to steam and diesels, then close once more officially for steam and then remain open to diesels only until 13 April 1970. (Win Wall, Strathwood Library Collection)

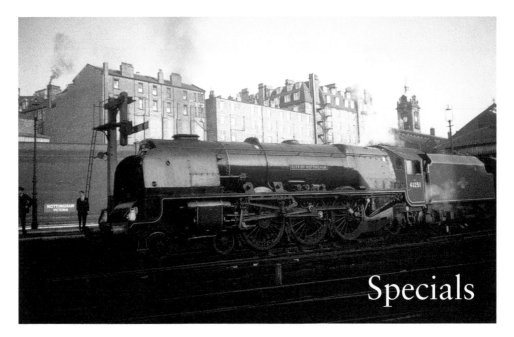

Specials

Boundary changes had been seen throughout the Nottingham area as the accountants did their sums and played with railway maps over the years. The opportunity to gain a photograph of Stanier Pacific No. 46251 *City of Nottingham* in the same frame as the sign for Nottingham Victoria was too good to pass up for our quick-thinking cameraman on 9 May 1964. Taken at around 07.30 in the morning, the big Pacific would head off away from the area along the old Great Central mainline for Oxford, Didcot, Eastleigh and Swindon as the East Midlander No. 5 Railtour organised by the RCTS. (Chris Forrest)

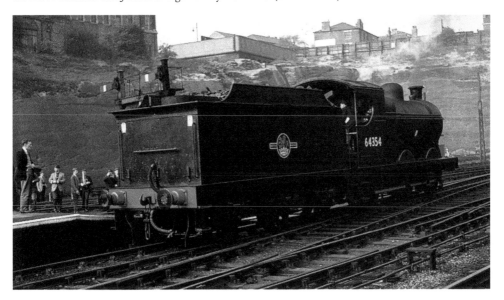

Great Central motive power in the shape of Class J11/3 No. 64354 backs onto a special at Nottingham Victoria on 14 October 1962. The train had started the day at Marylebone behind Class B16/2 No. 61438 which had just come off the train which was running about twenty minutes down at this time. The J11/3 from 36E Retford shed would be taken out of traffic after this tour and went to Gorton Works for breaking up which was carried out in May 1963. (Strathwood Library Collection)

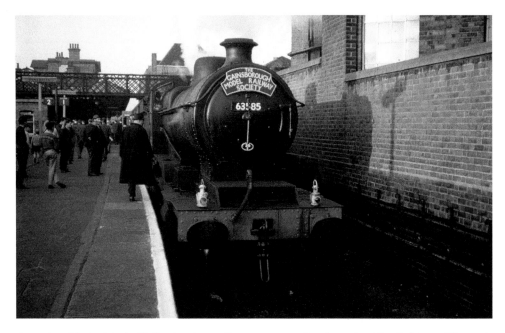

A continued link with the G. C., this time at Doncaster on 12 October 1963 with a Robinson Class 04/8 No. 63785. This tour, arranged by the Gainsborough Model Railway Society, took in many lines around South Yorkshire. One of the most popular light entertainment shows on television at the time was *The Dick Van Dyke Show*, also starring Mary Tyler Moore. (John Rowe)

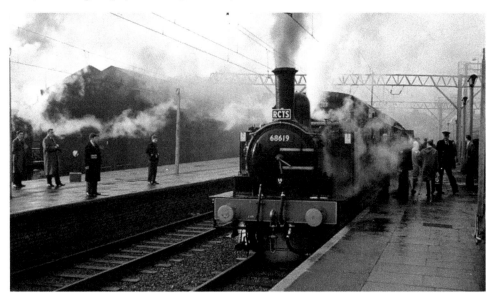

After running from Liverpool Street, Class J69/1 No. 68619 has a chance for a breather while stopping at Enfield Town on an inclement 12 November 1960. The London Branch of the RCTS had organised this Great Eastern Suburban Railtour as the full electric services were due to begin. It was booked for an interesting route utilising many junctions around a forty-mile stretch of East London's lines with a load of five well-filled coaches full of spotters. By the time the train had made it to Walthamstow Wood Street, a pilot in the form of Class N7/3 No. 69687 was put on to allow the poor little 0-6-0T to recover boiler pressure by the time Chingford was reached. (Strathwood Library Collection)

In contrast, very few people seem to have turned out at Bartlow to witness Class J15 No. 65478 make smoke as she passed through on 30 April 1961. Perhaps everyone was hiding under their beds, as it was on this day that the USSR detonated the world's largest ever nuclear bomb in a test that caused uproar in the west. It was subsequently revealed that the Soviet bomb was 58 megatons – the world's biggest explosion to date and nearly 4,000 times more powerful than the atomic bomb dropped on Hiroshima in 1945. The explosion came at the height of the arms race between Russia and America during which time each country successfully produced bigger and more sophisticated thermonuclear weapons. Many would not sleep easy in their beds at this time. (Vincent Heckford, Strathwood Library Collection)

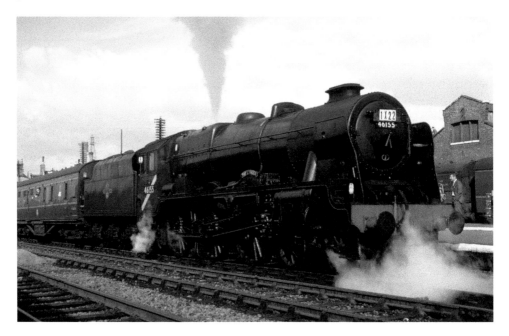

The LCGB organised The Pennine Limited Railtour of 19 September 1964, starting off at St Pancras and reaching the ECML via Peterborough East, where we see Royal Scot No. 46155 *The Lancer* which came off the tour here. It was replaced for the next leg to Sheffield Victoria by Class A1 No. 60128 *Bongrace*. After servicing the Royal Scot would head off to meet the train again later in the day at Nottingham Victoria to bring the tour back along the Great Central mainline to Marylebone. (Frank Hornby)

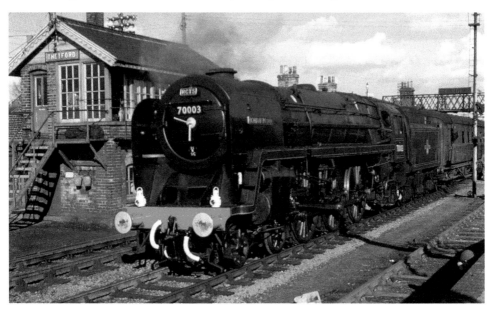

The London Branch of the RCTS was keen to not let the end of Great Eastern lines steam operations go by without commemoration. Having worked the tour to Norwich from Liverpool Street in the morning, the participants were then treated to a trip to Foulsham and back via Swaffham to Thetford, where the Britannia came back onto the train for a run back to London via Ely and Cambridge on 31 March 1962. (Strathwood Library Collection)

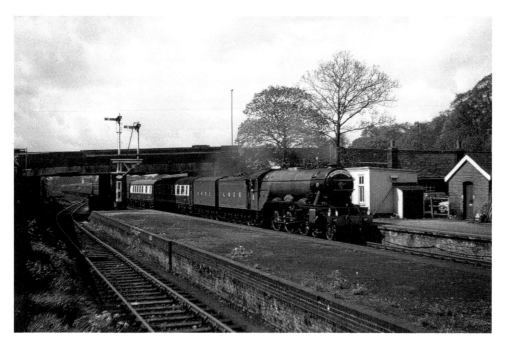

Making a special run to Norwich as well a few years later was No. 4472 *Flying Scotsman*, making full use of the second tender as watering facilities had been removed at so many locations by now around the region. Our cameraman positioned himself at Trowse station, which had been closed since 1939. (Michael Beaton)

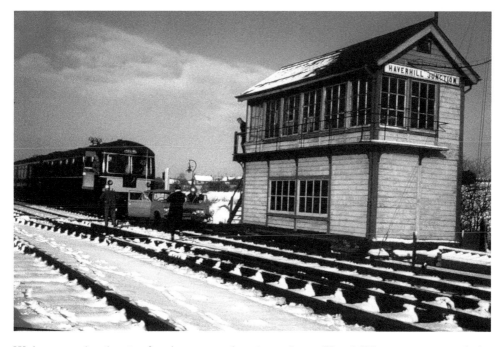

We have no real explanation for what seems to be going on here at Haverhill Junction in 1966, with this Vauxhall Velox illegally parked in the path of a Cravens diesel multiple unit engaged in a special working. But is has certainly stopped matters for the time being, until the signalman sorts something out! (Vincent Heckford, Strathwood Library Collection)

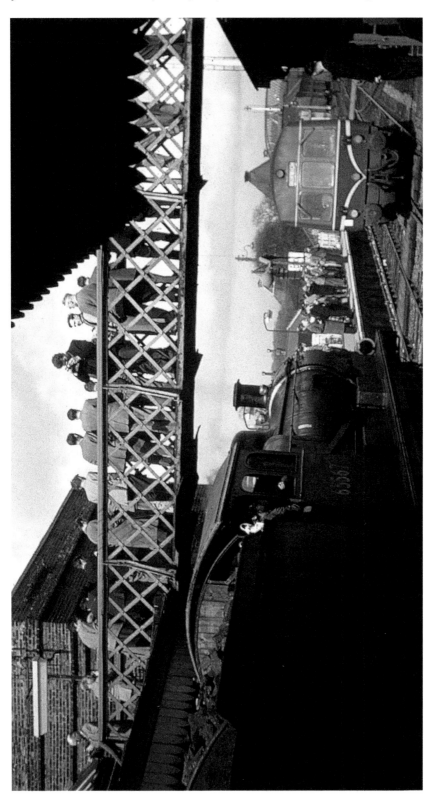

We have already touched on the Great Eastern Commemorative Railtour of 31 March 1962. Tour participants have taken the chance to stretch their legs and grab a snap or two as their train headed by the Class J17 No. 65567, which we saw at Doncaster Works, waits for the passage of Metropolitan Cammell diesel multiple unit at Dereham. The Shadows had just gone to number one with that catchy tune 'Wonderful Land'. Film Director David Lean had just triumphed at the Oscars in 1962 for his film *Lawrence of Arabia*. (Strathwood Library Collection)

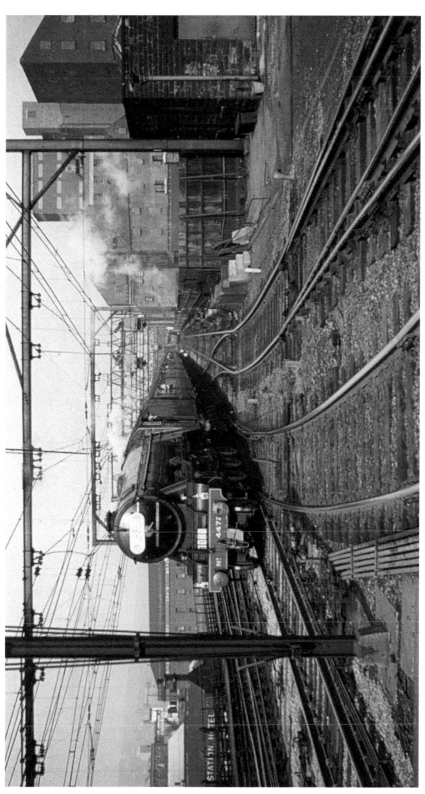

A jointly arranged Great Central Railtour by the Stephenson Locomotive Society and The Manchester Locomotive Society brought No. 4472 *Flying Scotsman* as the main motive power for their train on 18 April 1964. The tour had begun at Manchester Central at 08.28 and many spotters were enjoying the fine morning as they approached Sheffield *Victoria* at around 09.53, no doubt hoping to catch the numbers of any locomotives around the station. The train continued via Shirebrook North and Nottingham *Victoria* to Marylebone, returning the passengers to Manchester Piccadilly at 22.55. (Trans Pennine Publishing)

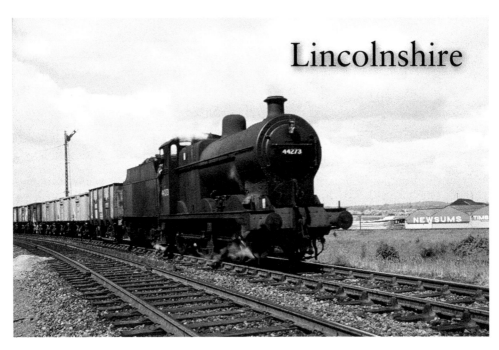

Lincolnshire

Heading a rake of coal empties at Gainsborough is Derby built Class 4F No. 44273 seeing out its last few weeks of use in the summer of 1962. Allocated to 31B March from February 1960, this was to be this engine's last engine shed, with it spending around a year stored here after being taken out of traffic before being hauled to Doncaster Works in September 1963. (John Rowe)

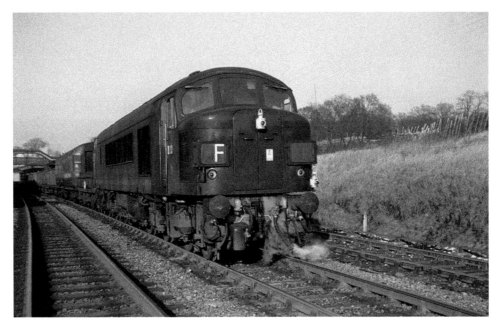

Another freight working at Gainsborough which enjoyed two stations, one at Lea Road and the other at Central. Both originally joint stations, the latter with the Great Central Railway and the Great Northern and the second joining the Great Northern Railway with the Great Eastern Railway. Still in original as-built condition is Peak Class D13, showing the connecting doors fitted to the first few of these engines. (John Rowe)

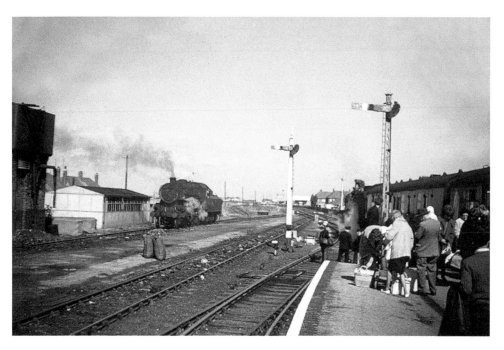

Holiday traffic was also still very important to the railways of Lincolnshire in the sixties, as witnessed here at Mablethorpe on 12 August 1963. An Ivatt 4MT Mogul runs off while the crew for this passenger train prepare their engine for departure. Of interest is one of the pre-cast concrete signal posts that were once familiar across the county. (Strathwood Library Collection)

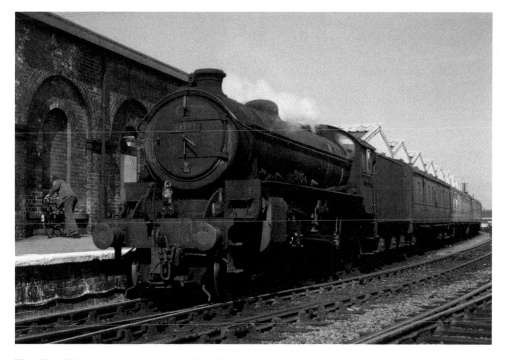

This Class B1 No. 61302 has just arrived from Peterborough at Grimsby Town in 1963. I wonder if that bicycle has ridden in the van behind the locomotive? (John Rowe)

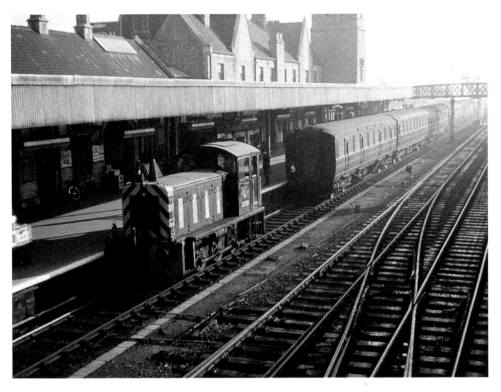

Lincoln Central station had the services of Drewry-built diesel shunter D2299 in this visit during the winter of 1961. (John Rowe)

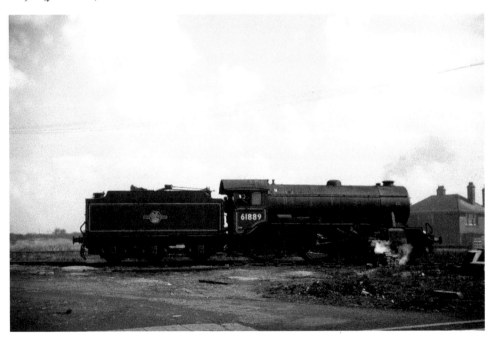

Another engine in its last year of service in May of 1962 was Class K3 No. 61889 seen at Immingham, no doubt having come off a fish working from the docks here. (Strathwood Library Collection)

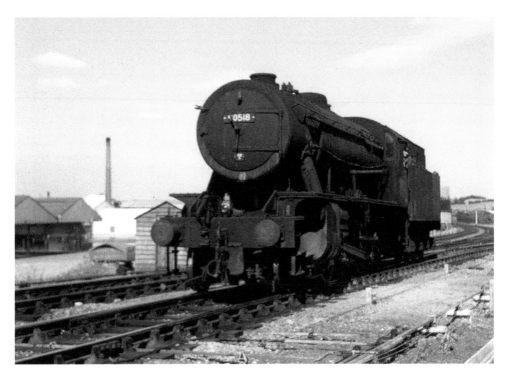

The familiar sounds of 'Dub Dees', also known as 'Bed Irons', were often heard around Lincolnshire in the early sixties. This example, No. 90518, is seen running light engine near Gainsborough in 1963. (John Rowe)

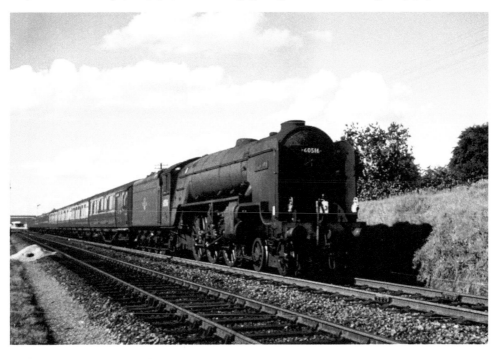

Named after the Irish-bred racehorse which won the 1944 Oaks was Class A2/3 *Hycilla* as she offers little exhaust on a very hot day in the summer of 1961 when photographed at Gainsborough. (John Rowe)

A short pick-up goods was recorded at Gainsborough in April 1964. In charge was Class B1 No. 61348, which had been moved from 40B Immingham to 36E Retford in January 1964. This was the month that Bob Dylan made his first entry into the UK charts with 'The Times They Are A-Changin', oh so true … as by the end of 1964 the original 409 Class B1 locomotives had been whittled down to 172 examples. (John Rowe)

South of Doncaster

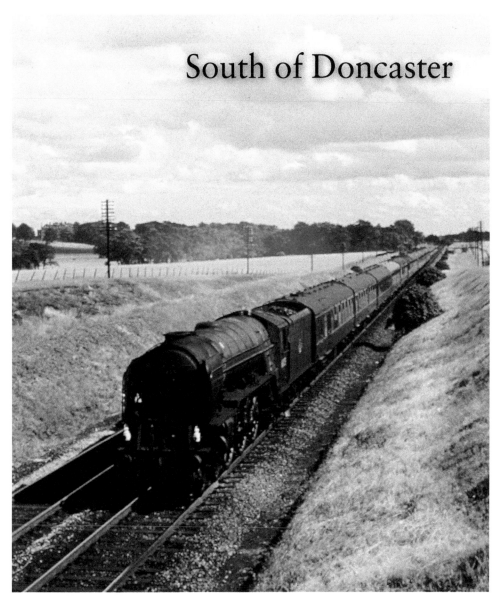

Running easily on the level stretch of the East Coast Main Line at Rossington is Class A1 No. 60125 *Scottish Union* on 21 July 1962. Brazil had won the 1962 football World Cup the month before in Chile. The tournament also staged one of the most notorious matches in FIFA World Cup history – the 'Battle of Santiago' between Italy and Chile, in which two Italians were sent off and one had his nose broken by a solid left-hook from a Chilean player. (Strathwood Library Collection)

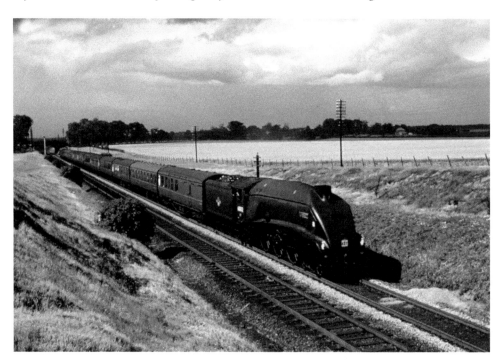

Taken on the same day at Rossington was this shot of Class A4 No. 60032 *Gannet*, as the sky begins to threaten on a muggy day. The permanent-way gangs have obviously been trying to keep the menace of lineside fires under control in both of these views. (Strathwood Library Collection)

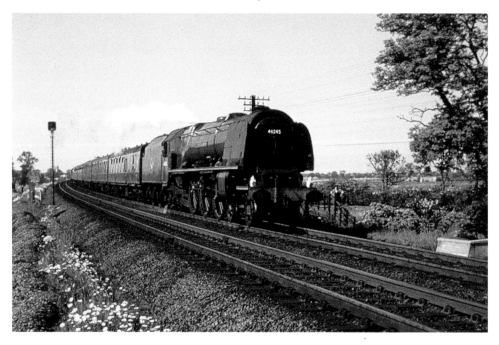

During the last weeks of regular Pacific running into King's Cross we see No. 46245 *City of London* going very well at Bawtry, running past the daisies along the lineside; at least one local worker stops for a minute to watch the passing special on 6 June 1963. (John Rowe)

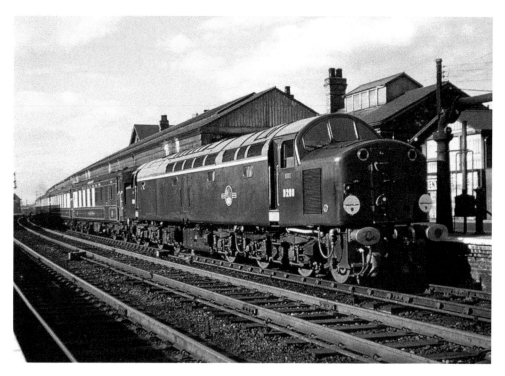

Sent new to 34B Hornsey in July 1958 was English Electric Type 4 D208, now based out of 34G Finsbury Park from April 1960, when it was seen heading the Sheffield Pullman at Retford. (John Rowe)

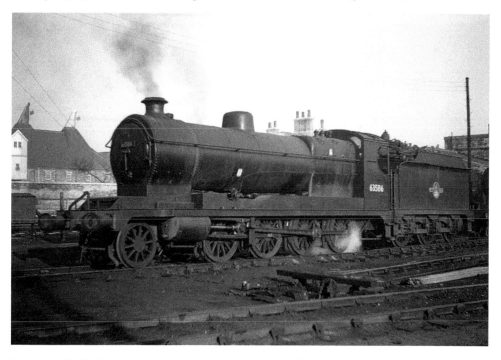

Stopping off at Retford we take the chance to visit the ex-Great Central shed, where a Class O4/1 No. 63586 was ready to leave the motive power depot the following year in 1961. (John Rowe)

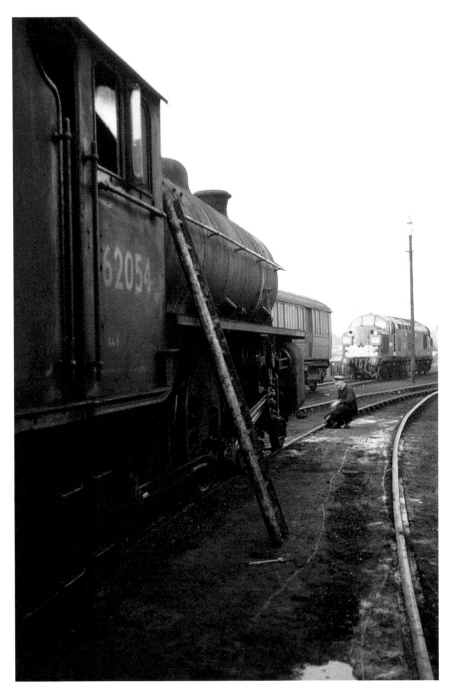

An English Electric Type 3 has been stabled short of the depot's tool van in this scene at Retford on 2 January 1964 while the fitters attend to Class K1 No. 62054, which had been stopped over the New Year. Although the first two James Bond films had been a success, the coming year would see *Goldfinger* become, for a while, the fastest-grossing film of all time, eventually taking more than $125 million. Bond had gone from being a reasonably successful film character to being an enormous worldwide phenomenon that had us all going to the cinema to enjoy his adventures. (Win Wall, Strathwood Library Collection)

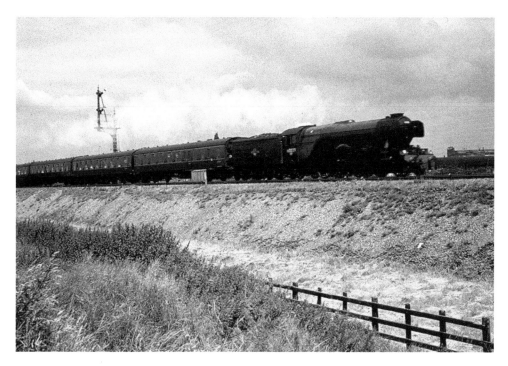

Looking very smart near Gamston in the early summer of 1961 was Class A3 No. 60109 *Hermit*. The metamorphosis of this A3 had started in April 1959 with the fitting of a double chimney and continued in February 1961 when the German style of smoke deflectors were attached. But these modifications were to be of little longer-term value as the engine was withdrawn in August 1962. (Trans Pennine Publishing)

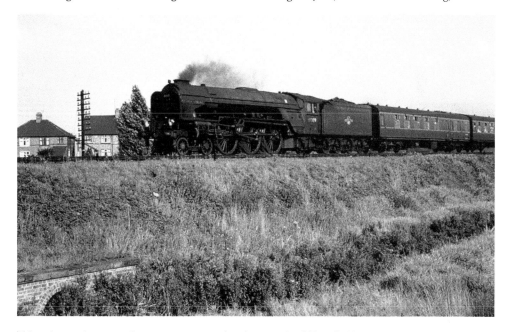

Taken during that same pleasant summer was this photograph of Class A1 No. 60119 *Patrick Stirling* heading the other way near Gamston. This A1 would spend its last seven and a half years as a 36A Doncaster-based engine and a regular on the southern half of the ECML. (Trans Pennine Publishing)

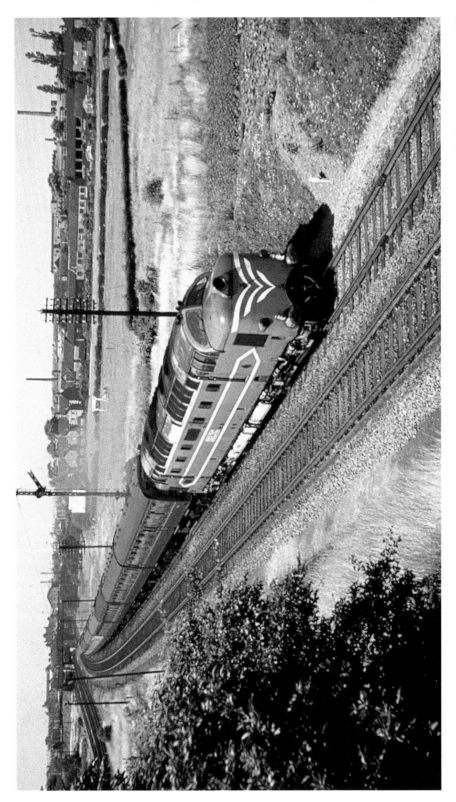

Continuing south to Newark we hear the distinctive roar of the Napier Deltic engines and see the Prototype Deltic burst into view with the familiar blue exhaust haze left in its wake. This notable locomotive arrived on the Eastern Region for trials in January 1959 based at 34B Hornsey, but it was prematurely taken out of service in March 1961. We estimate that this shot was taken in the summer of 1960. (Trans Pennine Publishing)

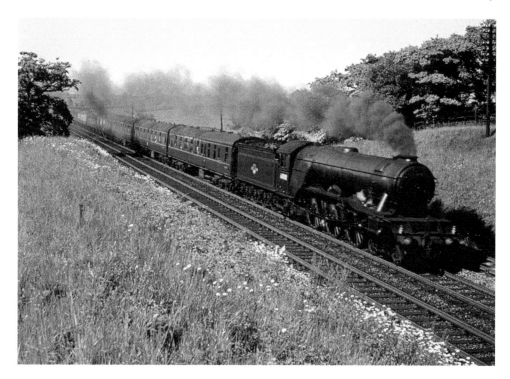

At a point close to Stoke summit the same cameraman recorded Class A3 No. 60108 *Gay Crusader* in the same 1960 summer as the ox-eye daisies are in bloom alongside the track. (Trans-Pennine Publishing)

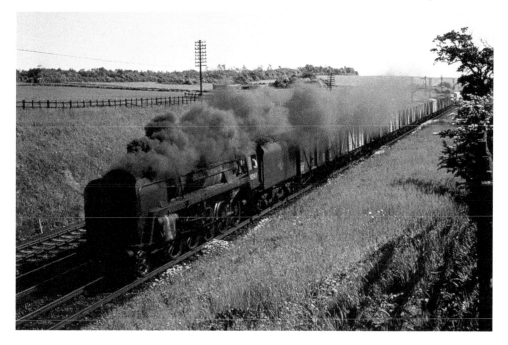

A fast-running fish train is also at Stoke Summit with Class 9F No. 92143. It would appear that the fireman has just put a few rounds of coal through the firehole door by the way that the exhaust is hanging around the front of the locomotive. This view would have been taken in the summer of 1961. (Trans Pennine Publishing)

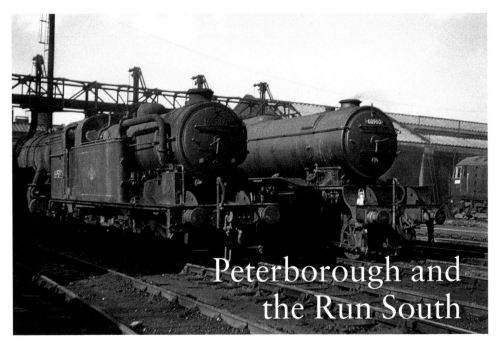

Peterborough and the Run South

Two of Sir Nigel Gresley's design are on shed as we arrive at 34E New England for a visit on 10 April 1960. The Class N2/4 No. 69587 was to be the very last of her type delivered in May 1929 from Hunslet in Leeds, while Class V2 No. 60902 started in traffic during March 1940 from the LNER locomotive works at Darlington. To the right can be glimpsed one of the North British Locomotive Company's Bo-Bo diesels that started their troubled lives working services from King's Cross. (Frank Hornby)

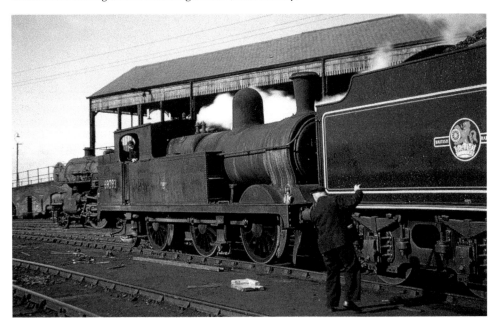

Shed pilot on this day was Class N5 No. 69293, was attending to its duties by moving a B1 that was out of steam. One of the big films of the year was *The Time Machine* starring Rod Taylor, based on the H. G. Wells novel. Now what would you do with one of those machines today? (Norman Browne, Strathwood Library Collection)

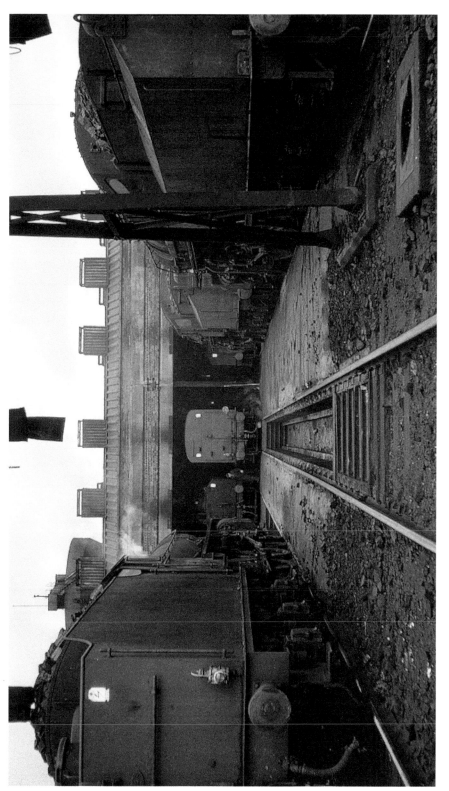

A good mix of engine types can be made out on shed in this view of New England in May 1964. There had been subsheds from here at Bourne, Stamford and the last at Spalding closed on 7 March 1960. The parent shed had been extensively rebuilt during 1952/3 and retained an allocation of over 100 engines at the beginning of the decade. (Win Wall, Strathwood Library Collection)

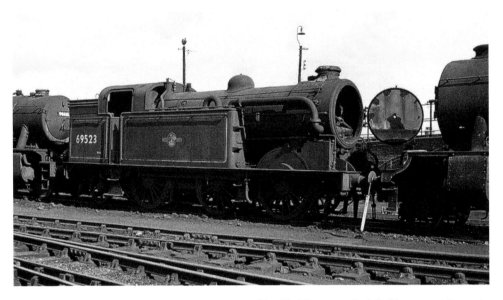

In store and ultimately to be saved for preservation was Class N2 No. 69523, which had been set aside in 1962. This class of locomotive came from five separate workshops with the largest batch being built by the North British Locomotive Company in Glasgow. Aside from Doncaster, others were built by Hunslet as we have seen with Beyer Peacock and Yorkshire Engine Company chipping in with batches as well during a ten-year construction period. (Trans Pennine Publishing)

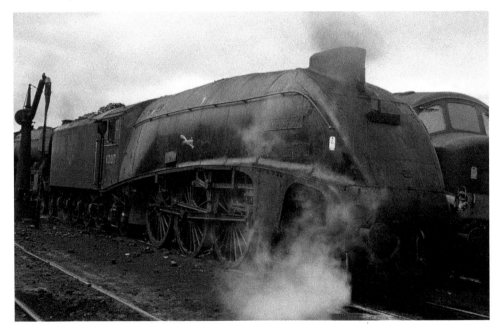

With the replacement traction available in the form of a Peak, days were numbered for Class A4 No. 60017 *Silver Fox* when seen at New England on 16 June 1963. A former textile worker from the Soviet Union was to become the first woman in space on this day. Lieutenant Valentina Tereshkova, 26, was the fifth Russian cosmonaut to go into the Earth's orbit when her spaceship Vostok VI was launched at 12.30 Moscow time. Moscow Television broadcast the first pictures of the elated blonde – code-named Seagull – ninety minutes later. (Strathwood Library Collection)

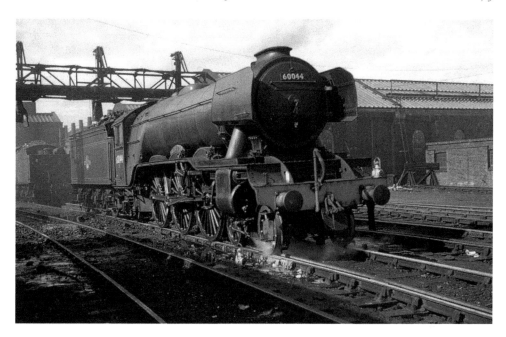

Looking much more respectable a few years before in 1962 was Class A3 No. 60044 *Melton*. Two very different police television shows would go to air in 1962. The longest running was *Police 5*, which ran variously until 1992. But certainly the most popular was *Z Cars*, which was to portray a very different view of police work from the established Dixon of Dock Green. The success of the show must have boosted sales for Ford and their Zephyr and Zodiac models. (Strathwood Library Collection)

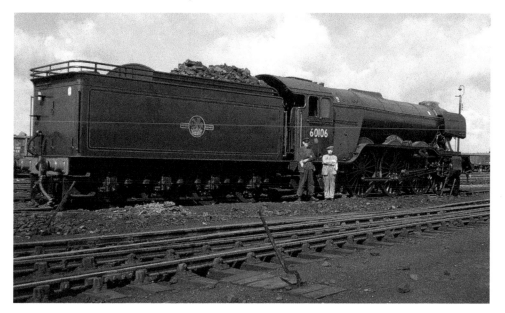

The crew of this well presented A3 No. 60106 *Flying Fox* shows that a stout pair of boots for work on the footplate was desirable on 3 May 1964. This was the era of Mods and Rockers and on this day at various resorts across the south coast, hundreds were being arrested as pitched battles took place between youths that favoured motorbikes and leathers, with those who preferred scooters and Parka coats.
(Win Wall, Strathwood Library Collection)

Withdrawn A3 No. 60062 *Minoru* was being shunted around the shed by a diesel shunter on 3 January 1965. The Pacific had been taken out of traffic a few weeks before and would ultimately become one of five class members sold from New England to scrap-dealers Kings of Norwich in 1965. (Stewart Blencowe Collection)

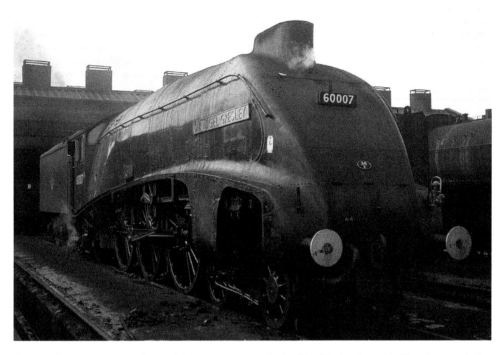

Another Gresley locomotive destined for preservation on shed at New England was the Class A4 named after the great designer himself in July 1963. One of the big hits of the year was 'Glad All Over' by the Dave Clark Five. (Richard Sinclair Collection)

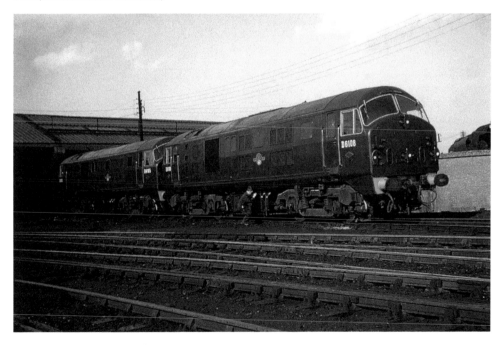

A closer look at a pair of those North British Locomotive Company's diesels as a fitter peers into one of the beasts. This pair, D6105 and D6108, was being prepared for transfer to 65A Eastfield, which would be carried out the next day. (Frank Hornby)

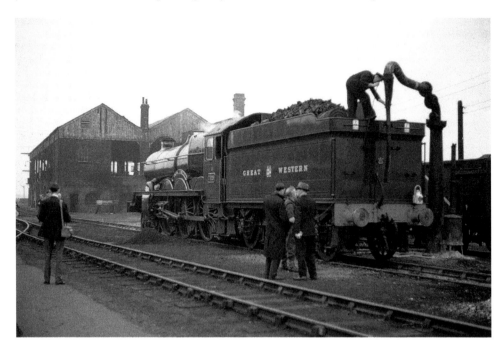

The peculiar coaling stage of New England sets the scene as No. 7029 *Clun Castle* is being prepared for a special run on 30 September 1967. Bringing up the train was D1503 from King's Cross as far as Peterborough, where the Castle would be put on for the long run to Carlisle via Ais Gill. Hence the carefully stacked coal in the tender and the fireman about to ensure his steed was well watered before setting off. (Strathwood Library Collection)

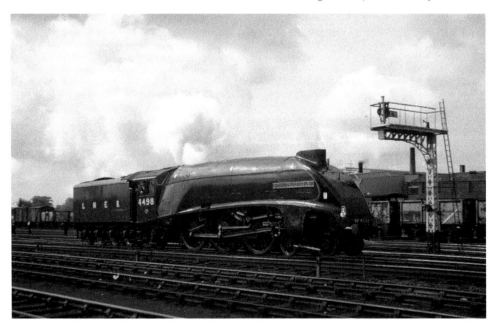

A similar routine was carried out several weeks before with another diesel bringing the tour train from King's Cross as far as Peterborough. In this instance A4 No. 4498 *Sir Nigel Gresley*, in its preserved guise, would make a dash up the ECML to Newcastle and back. The tour would allow three hours at Newcastle where no doubt many of those on the train would bunk 52A Gateshead during the turnaround. (Michael Beaton)

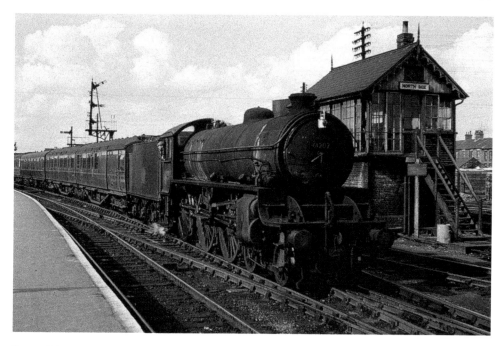

Less well kept was Class B1 No. 61207 when seen running into Peterborough past the North signalbox in 1962. The leading pair of coaches is part of a Gresley articulated set. Comparisons with the picture opposite show the work of some overdue painting keeping the assets of the railway in better condition. (Trans Pennine Collection)

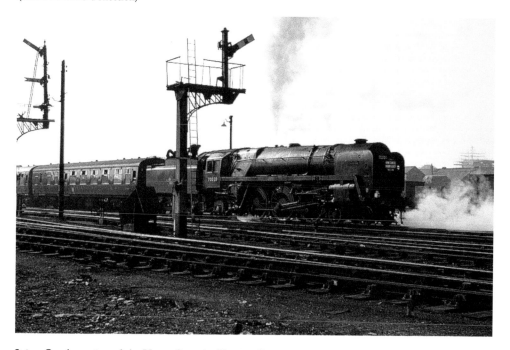

It is 4 October 1964 and the Home Counties Touring Society are going to York and back behind Britannia Pacific No. 70020 *Mercury*. The opportunity to take water was being taken while the engine was obviously steaming well at this point. (Stewart Blencowe Collection)

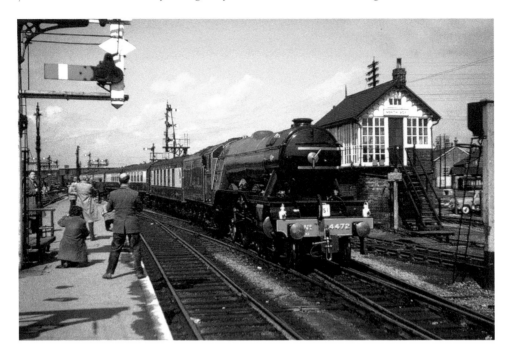

A Pullman special was run on 10 April 1965 with No. 4472 *Flying Scotsman* at its head. A number of cameramen and spotters were out to enjoy the spring sunshine and the sight. Every weekday afternoon, *Crossroads* had been appearing on our television screens since November 1964, with tales around the motel. The programme had become very popular and enjoyed some high-profile fans, including Mary Wilson, the wife of the then Prime Minister Harold Wilson. (Michael Beaton)

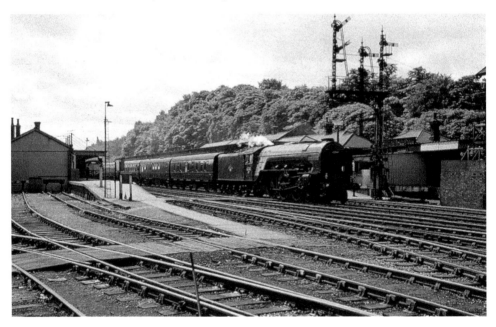

A Cravens diesel multiple unit is in the platform as Class A1 No. 60141 *Abbotsford* rolls through on the fast on 18 June 1961. The big tune selling fast at the record stores was 'The Runaway' from Del Shannon. (Vincent Heckford, Strathwood Library Collection)

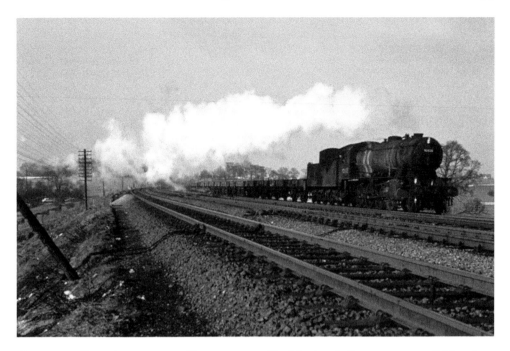

Also going well was Austerity 2-8-0 No. 90428 on a cold 2 March 1963. Some snow was still lying about from the big freeze which had interrupted so many services in the previous weeks across the country. In a season with such a large number of fixtures being postponed, the Football League Championship went to Merseyside and Everton F.C. (Strathwood Library Collection)

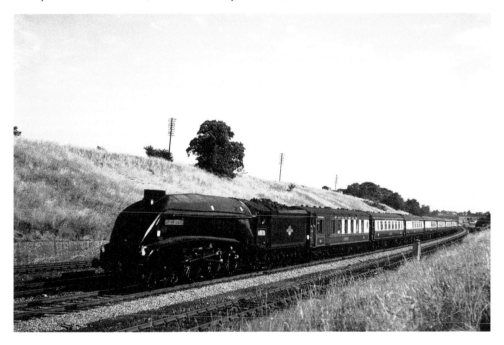

Taken on a very different day in warm summer weather on 5 July 1961 was this pleasing shot of Class A4 No. 60026 *Miles Beevor*. No doubt the passengers within the comfortable Pullman cars would be enjoying their trip as they made progress between Potters Bar and Brookmans Park. (Phil Nunn Collection)

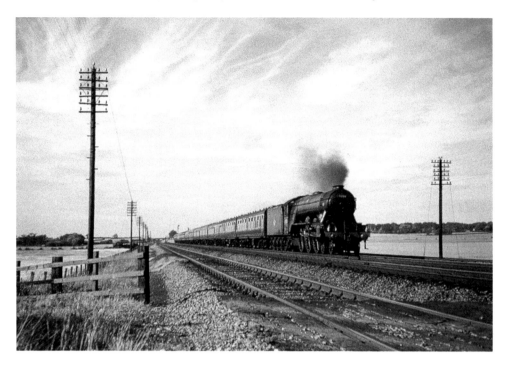

Out on the lineside on this same day was another cameraman who was watching the procession of trains at Orford Cluny, where he captured Class A3 No. 60103 *Flying Scotsman* before the fitting of smoke deflectors, which took place in December 1961. (Vincent Heckford, Strathwood Library Collection)

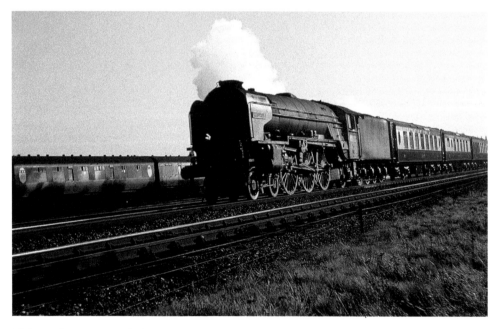

Making a fine picture in the low autumn light on 15 November 1960 was Class A1 No. 60130 *Kestrel*. This name had originally been carried by an A4 No. 4485, which was renamed *Miles Beevor*, who was Chief General Manager of the LNER in November 1947. The A1 gained the name *Kestrel* on 20 July 1950 after almost two years in service. (Phil Nunn Collection)

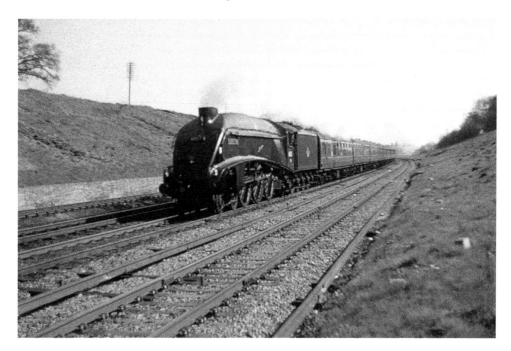

Between Brookmans Park and Potters Bar, approximately thirteen miles from King's Cross, is again the location where we find A4 Pacific No. 60017 *Silver Fox* at speed on 1 May 1962. In the following month this A4 would be moved to 34E New England from many years at Top Shed. Within a few more months she would be withdrawn. (Strathwood Library Collection)

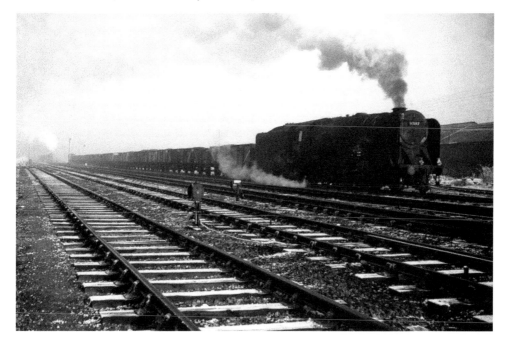

Back to the big freeze of 1963 and Class 9F No. 92187 is progressing along the southern stretch of the ECML with a long rake of coal wagons. In the distance V2 No. 60864 is gaining fast on a fitted vans train and will quickly overtake the big Standard. (Vincent Heckford, Strathwood Library Collection)

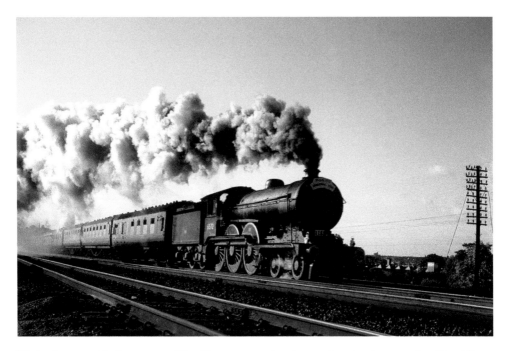

Having been set aside for two years, Class B12 was steamed again to make a circuitous run from Broad Street via Cannonbury Junction – Hitchin – Bedford – Northampton – Towcester – Stratford upon Avon – Hatton – Rugby – Willesden and back to Broad Street. This run was only blessed with sunshine for part of the day on 5 October 1963, where we see the engine making smoke near Hatfield. (Phil Nunn Collection)

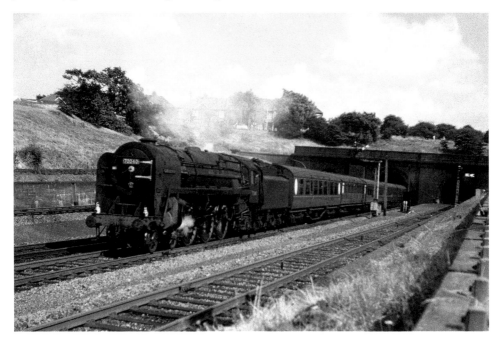

Running fast near Hadley Wood in 1962 was Britannia No. 70040 *Clive of India*, most likely on a service for Grimsby. This was one of several of her class based at 40B Immingham at the time, until they migrated north to Carlisle in early 1964. (Phil Nunn Collection)

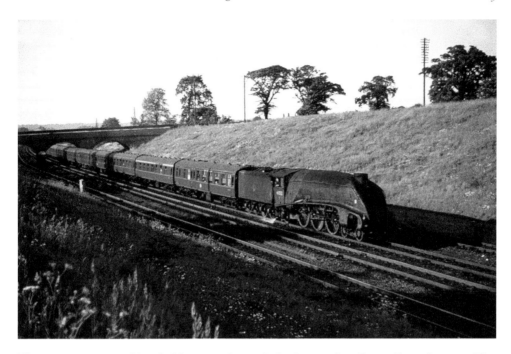

The injectors are on as Class A4 No. 60032 *Gannet* drifts along easily at Potters Bar in June 1963. This was the month that Top Shed was to lose its famed collection of East Coast thoroughbreds. Some would be withdrawn while others more fortunate would be moved further north. A case of progress the ogress. (Strathwood Library Collection)

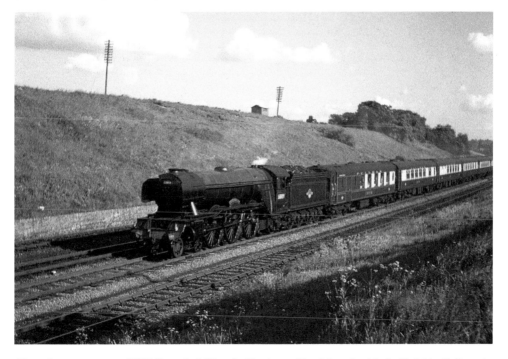

Along the same section of ECML we find Class A3 No. 60109 *Hermit* in 1962 with the Yorkshire Pullman in fine fettle as befits such a train. (Phil Nunn Collection)

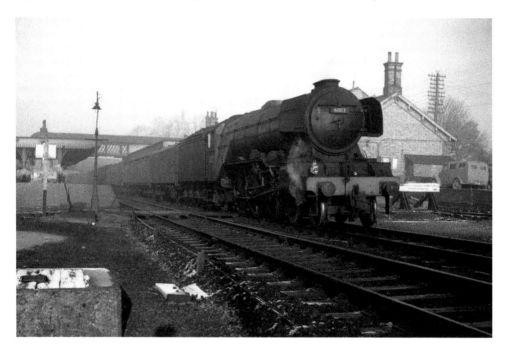

Cleaning locomotives during the harsh winter of 1963 would have been difficult to say the least, besides which most available staff would have been kept busy preventing the railway from grinding to a halt as everything froze solid. However, Class A3 No. 60112 *St Simon* does not look too bad when it passed through St Neots early in 1963. (Vincent Heckford, Strathwood Library Collection)

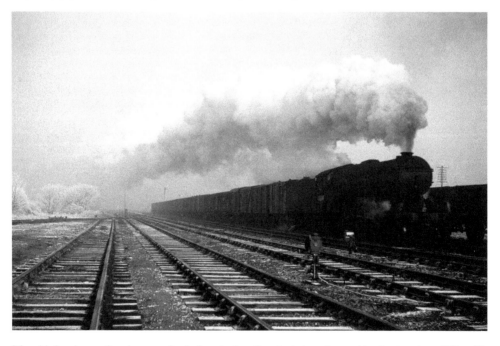

Most likely taken earlier the same day, before the hoarfrost had cleared, was this pleasing shot of Class V2 No. 60864 as it overtakes the 9F we have already seen earlier at St Neots.
(Vincent Heckford, Strathwood Library Collection)

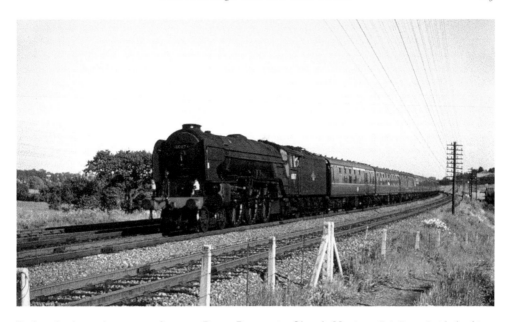

Back to that last early summer of steam at Potters Bar to enjoy Class A1 No. 60117 *Bois Roussel* with the driver leaning out to gain a better view of signals on the gentle curves here. This unusual name was taken from the winning horse of the 1938 Derby in front of a tremendous pre-war crowd of 500,000 spectators packed onto Epsom Downs. (Strathwood Library Collection)

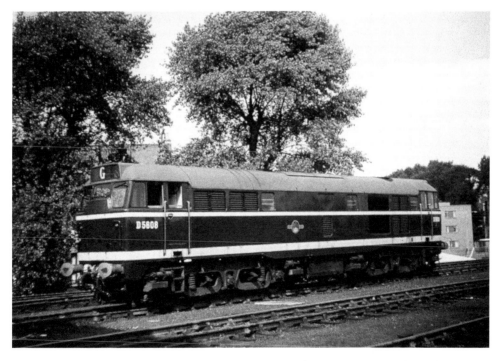

Delivery of this Brush Type 2 D5608 was to 34B Hornsey on 21 April 1960, just three days before the new facilities at 34G Finsbury Park opened for traffic. On a visit to the capital our cameraman made his first visit a few weeks later to this new depot when he took this shot for us to enjoy long after the depot had itself closed. (Noel Marrison)

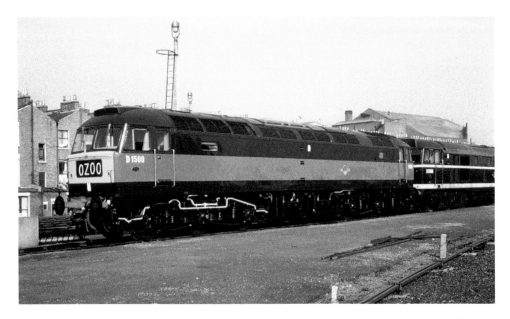

Brand new and straight out of the tissue paper was this bigger brother diesel from manufacturers Brush of Loughborough with the first delivered of their standard Type 4 design D1500 on 28 September 1962 again taken in the company of another Type 2 at Finsbury Park. A few days later and 'Telstar' from the Tornados would go to number one. (Strathwood Library Collection)

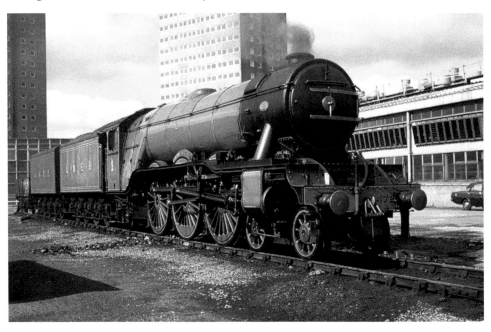

Most of us will recall watching the film made for television of No. 4472 *Flying Scotsman* and the epic run on 1 May 1968 from King's Cross to Edinburgh to commemorate the 40th anniversary of the first non-stop run. With the end of steam officially later in 1968, the locomotive's owner Alan Pegler looked for the possibility of taking the engine on a trip to the United States. The preparations for that visit involved the fitting of an American style hooter and a large bell; this work would be carried out at Finsbury Park, where we see the engine simmering at the time. (Graham Barklam)

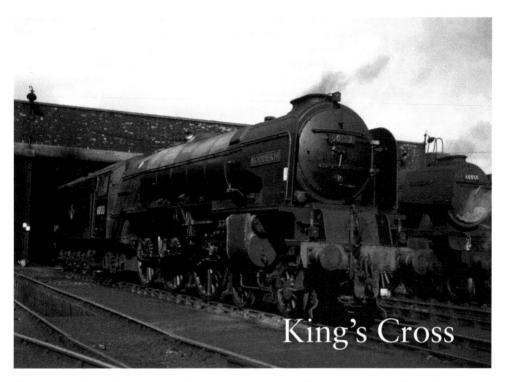

King's Cross

The traditional home for express steam locomotives a few years before had been at 34A King's Cross, or, as it was more popularly known, Top Shed. A well-presented Class A1 No. 60133 *Pommern* stands alongside a rather hard-worked Class A3 No. 60050 *Persimmon*. This photograph was most likely taken after the thaw in 1963, before the shed closed completely on the 15 June 1963. (Vincent Heckford, Strathwood Library Collection)

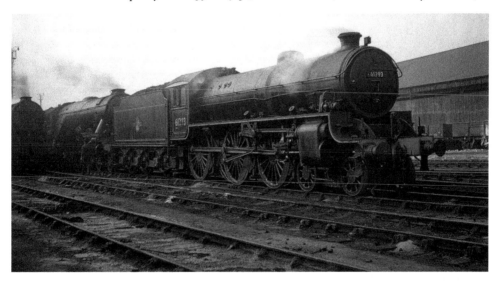

A fireman walks back towards the shed building while preparing his Class B1 No. 61393 on 19 March 1960. Far away in Africa, where many of the species of antelopes that many of this class were named after are found, there was trouble brewing. Just three days later the world was horrified when it learned of the Sharpeville shoot-out, when over fifty black people were shot dead by the police. The following year under pressure from the world South Africa declared itself a Republic. (Frank Hornby)

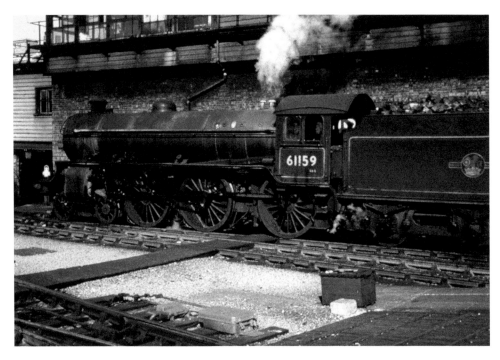

Moving to the platform ends at King's Cross once overlooked by that familiar signal box we find another Class B1 No. 61159 with safety valves feathering, getting away with her train in 1961. (Winston Cole)

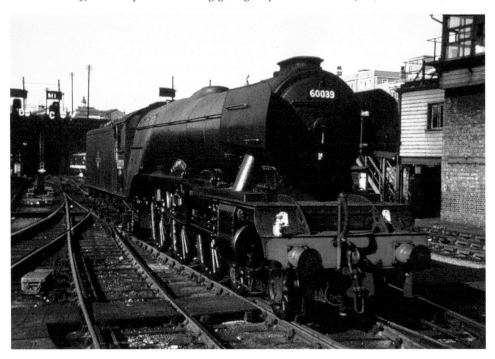

Newly fitted with her smoke deflectors was Class A3 No. 60039 *Sandwich* when seen backing out for servicing after being released from her train at the buffers at King's Cross. The diesel stabled by the tunnel entrance looks to be a Baby Deltic in this view also from 1961. (Winston Cole)

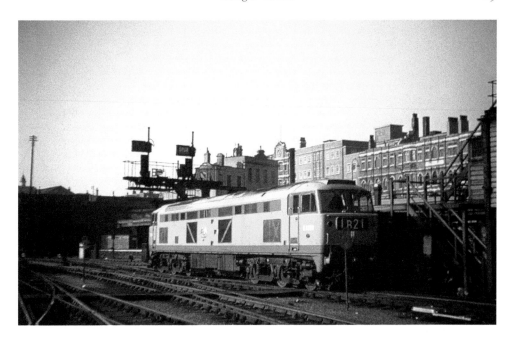

We saw D0280 *Falcon* earlier at Doncaster which when first put into traffic shed had a larger painted version of the unusual bird motif and name. Now we find this popular locomotive based at 41A Tinsley and frequently used on the Master Cutler Pullman service to London, here sporting the metal version of the bird of prey and a nameplate. We think this shot was taken in 1962 rather than 1963, the year when the Type 4 was returned to Brush to spend all of 1964 laid-up out of use at Loughborough. (Noel Marrison)

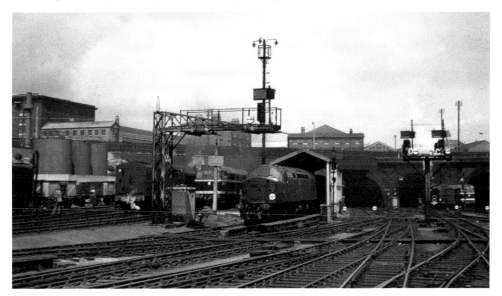

Spotters at the platform ends at the Cross always had something to keep them amused back then, whether it be the departures and arrivals of service trains, or punctuated by the occasional movement of goods trains in and out of the 'drain'. Then of course we could always watch the endless shuffling about of locomotives on and off the servicing point. This view was taken on 27 May 1961. Meanwhile over in Vienna a sensational Jimmy Greaves was to score his thirteenth goal of the season for England who would lose 3-1 away to Austria. (Frank Hornby)

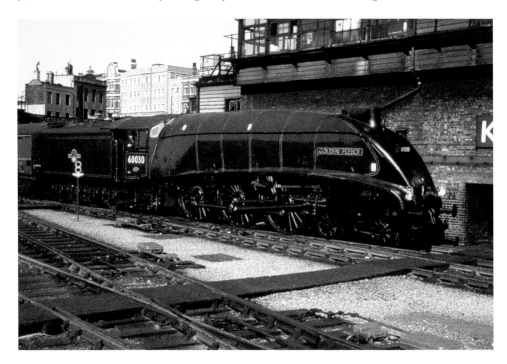

Arriving with The Elizabethan is Class A4 No. 60030 *Golden Fleece*, as usual, being one of Top Shed's A4s, kept so magnificently clean. (Winston Cole)

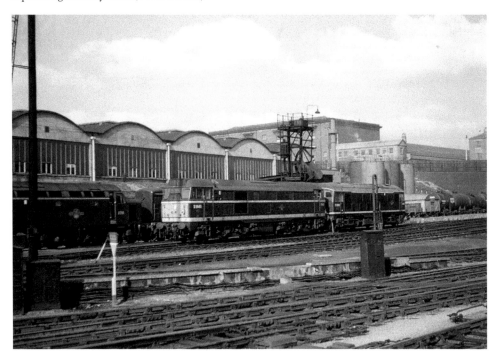

Occupying the stabling point on 24 February 1962 were a selection of diesels, including an English Type 4, and hiding behind the Brush Type 2 and Sulzer Type 2 is one of the British Thomson Houston Company's Type 1s. (Frank Hornby)

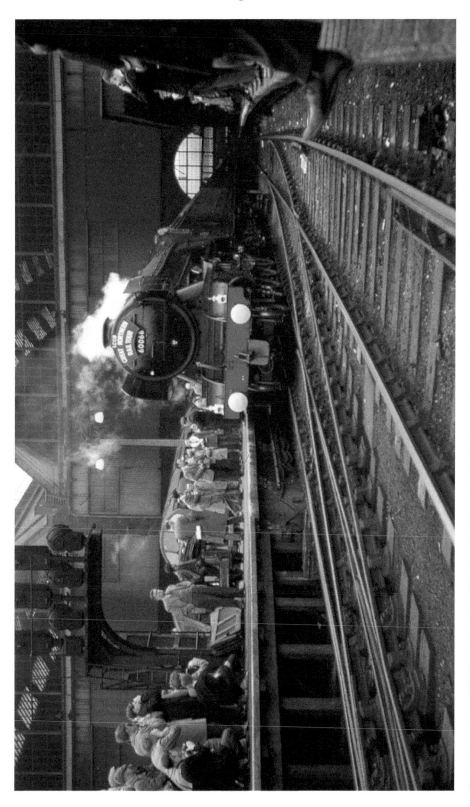

On 19 May 1962 the LCGB ran their Great Northern Rail Tour from King's Cross to Doncaster for a visit to the works. The outward run was behind Class A3 No. 60066 *Merry Hampton* with the return behind Class A4 No. 60017 *Silver Fox*. (Vincent Heckford, Strathwood Library Collection)

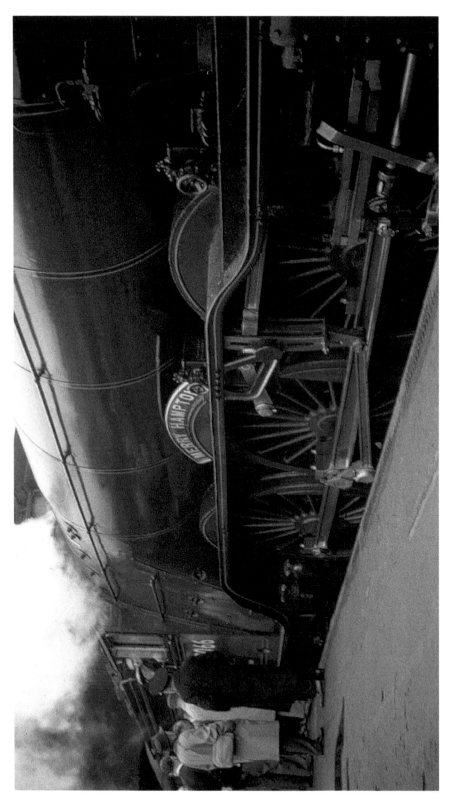

It is just before noon and departure time is booked for 12.10 and the station master is on the platform to ensure the smooth running of his station. The crew will be confident, having made the journey countless times before, no doubt with their faith in this well-prepared locomotive from Top Shed on 19 May 1962. (Vincent Heckford, Strathwood Library Collection)

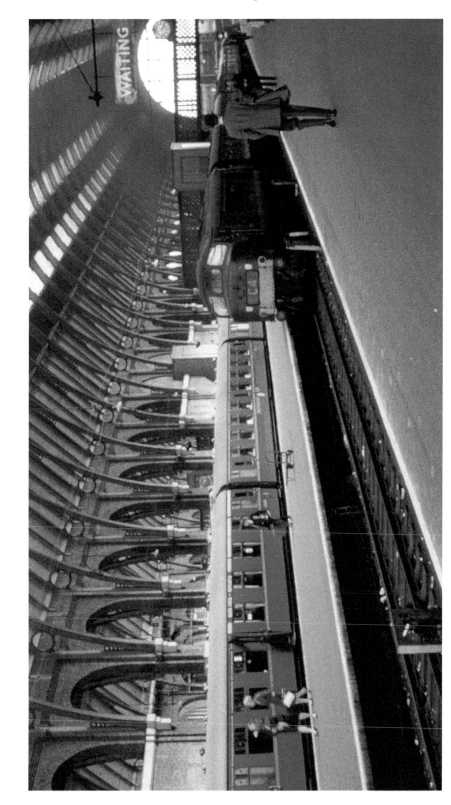

After the third week of June 1963, King's Cross would see very little steam activity and passengers would be carried by diesels such as this Peak from far away 52A Gateshead. Something else that would disappear during the sixties was the fashion for wearing bowler hats. The station was opened in 1852 and the station roof, the largest at the time, was supposedly modelled on the riding school of the Czars of Moscow. It is also rumoured that Queen Boadicea is buried beneath platform 8. The 1852 station was designed by the architect Lewis Cubitt, whose uncle and cousin were engineers on the construction of the Great Northern Railway. He also designed the Great Northern Hotel. (Tim Meredith)

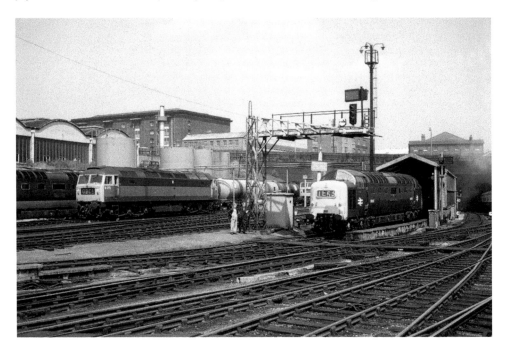

Class 47s and Deltics dominated the mix of locomotive types at the stabling point on a visit on 14 June 1968. Musically Gary Puckett and the Union Gap were coming to the end of their four-week stint at number one with 'Young Girl' and you would have been able to see them on the BBC's Top of the Pops on a Thursday evening at the time. (Frank Hornby)

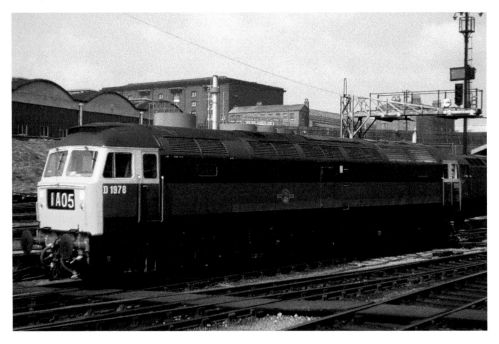

As early as April 1967 the adoption of full-yellow front ends was beginning, as seen here on the newly touched-up D1978. It was in the capital from 52A Gateshead and was sixteen months into its British Rail career at this date. (Strathwood Library Collection)

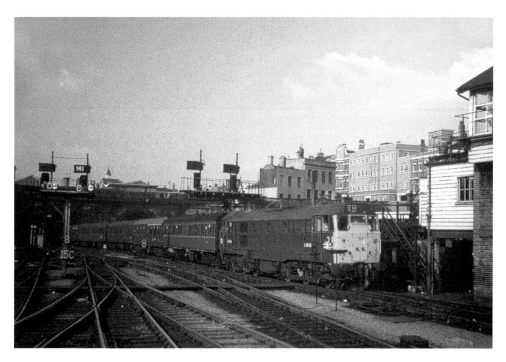

The repainting of the British Railways-built suburban coaches was still being carried out when a new Inter City blue-liveried Class 31 D5649 was arriving in 1969. (Len Smith)

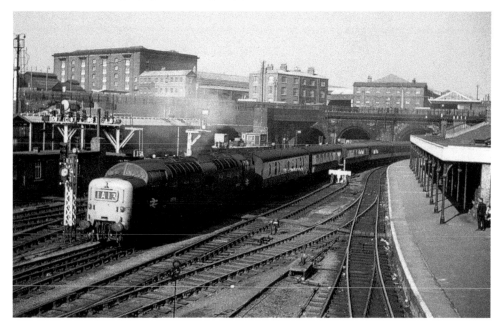

It was a big year in Hollywood and the cinemas of Britain in 1969 for Westerns with your choice of *True Grit, The Midnight Cowboy, Butch Cassidy and the Sundance Kid* and *Paint Your Wagon* hitting the big screen. Meanwhile many cameramen were ignoring the developing scene on the railway such as this view of D9019 *Royal Highland Fusilier* arriving at King's Cross with the Tyne-Tees Pullman, the stock of which was also in a mix of old and new liveries on 6 March 1969. (John Green)